Mosaic Making Techniques

Mosaic Making Techniques

Helen Hutton

Charles Scribner's Sons New York

First published 1966
New edition 1977

Library of Congress Catalog Card Number 77-72063
ISBN 0 684 15136 7 (hardback)
ISBN 0 684 15356 4 (paperback)
Printed in Great Britain

Contents

Acknowledgment

I wish to express my thanks and great indebtedness to the following who have given such willing help.

Jan and Zoe Ellison for technical advice on ceramics; David Lane for glaze recipes; Tom Fairs for information on glass mosaics; Hermia and Peter Eden for making a pavement for illustration in this book and also for the Alhambra tile plates: Kate Varney and the children of Cottenham Village College; my son Cailey for architectural drawings of a workroom plan; and other members of my family for their constant goading, encouragement and practical assistance; finally to my son Warwick for the drawings.

Cambridge 1966, 1977 H. H.

Introduction

This book has no pretensions to being an historial survey and analysis of traditional mosaic, nor is it an attempt to discuss the aesthetic merits of the great works of the past. It is, rather, a practical approach to a craft which comes close to being an art form, on a level that may be reached by most people. Fine publications are available which have covered all aspects of world famous mosaics; it is suggested that the reader studies as many of them as are available to broaden his horizon on the whole subject.

Many new materials and techniques have arisen lately, and practical methods of applying them is the chief aim of this book. The term mosaic, therefore, is used in the broadest sense to mean an arrangement of ordered parts to form a balanced unity—and not necessarily a permanent one, as was the case with traditional mosaics. Therefore we use such materials as seeds, bark, beans, wood sections and many other impermanent tesserae and combine this multiplicity into a balanced unit.

By the use of such permanent materials as smalti, vitreous, glass, stone and marble, however, an enduring and indestructible work of art may be created in this fascinating medium.

It is hoped that much of the book will be of interest to artists who have not yet tried their hand at mosaic making, but it is also intended to reach those others who are interested in doing creative work of this kind.

By its very nature, a simple, direct approach is a necessity for mosaic making, and this is probably the reason for the success of children when designing in this medium. Their naïve vision is directly interpreted into the mosaic form.

Design I

It will be noted that a number of the examples shown in this book are the work of children, working either as a group or individually, and their achievements may encourage adults with no art training to emulate their efforts. Most of us still have some of the freshness of a child's vision latent beneath our conventional approach to art. The act of manipulating the colourful tesserae into a design of some sort may well arouse inspiration.

In the hope that this book will not only teach techniques but will suggest ideas on pattern and composition, this section on design precedes the other chapters on the various methods of making mosaics. No work of any significance can result from an ill-conceived design and no amount of technical skill can mask this shortcoming. Perhaps arguably, I have assumed that one of the greatest rewards from making a mosaic lies in using materials that you have either found or made for yourself. Certainly this is true of children who are always more interested in finding novel types of tesserae or making their own ceramics to be fired by the pottery teacher in the school kiln.

Finally, it should be pointed out that although mosaic making may appear to be an expensive pursuit, (if you want to equip a workshop with a kiln and the accompanying apparatus and tools or if you use the precious Venetian smalti exclusively), it can also be one of the cheapest. Stones, pebbles, bark, broken crockery are all free for the finding. The adhesive and backing material remain the sole items to be bought.

Several mosaics by contemporary and well-known artists have been included but the main emphasis is laid on examples of the different techniques that may be learned by anyone. Some are simple designs and methods while others are more advanced and ambitious. The design factor is crucial whether you are preparing a small repetitive pattern or a large mural. To stress again—it is a popular misconception in this craft that a complete' mastery of technique will override any shortcomings of composition and design. In this medium as in others, without a clear understanding of the character of the material you are using, its qualities and limitations, its full potential cannot be realized.

A mosaic can be a dull wall cladding of pepper and salt repetition, durable and hygienic—if that is what you want—and as such is to be seen in countless bathrooms, kitchens and coffee bars. Indeed, you can buy ready-to-make kits in the form of paper squares with the tesserae ready glued in place to press instantly

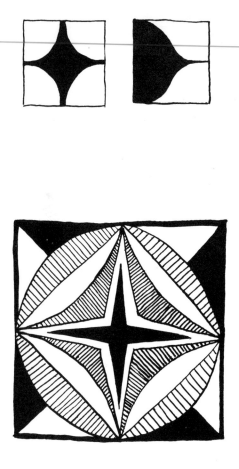

onto the prepared mortar bed. For those of you who lack interest, confidence or merely time, this is the obvious answer, but you will not know the sense of fulfilment in creating your own mosaic. It may be a surprise to find that you have a dormant sense of pattern and colour or that you are able to develop it with an ease which inspires you. This rhythm-colour pattern feeling has existed in man since primitive times as the early cavemen murals have shown, and all succeeding cultures have left their decorative stamp on walls, pavements and artefacts. Sumerian, Hellenic, Byzantine, Roman, Pre-Columbian and Polynesian are some of the civilizations which have made their contribution to this art form.

The ability to create decorative patterns is still to be found in the artefacts of the more primitive peoples although commercialization for the souvenir trade has brought about a sterile repetition of old motifs. With the revival of interest in some of the traditional crafts, the need to research into the sources of design becomes pressing, and partaking in this can be a fascinating pursuit. Industry is increasingly aware of the need for a more imaginative approach in this age of mass production and is prepared to subsidize it. Designing with tesserae is an excellent training for this.

IDEAS AND INSPIRATION FOR NON-FIGURATIVE DESIGNING

There are many ways of training the un-seeing eye to bring into focus a new world of forms, shapes and patterns that may have been invisible before. For the country dweller, the obvious sources are all around and his only problem lies in choosing the ones most suitable for his particular purpose and adapting them to a simple formula for his craft.

Nature offers an inexhaustible range of subjects: rock formations, patterns on stones, tree bark, rippling water, flint walls, seed cases, skeleton leaves or the markings on insects, butterflies or birds. Look at some of these under a magnifying glass, or better still photograph them and then enlarge sections to find their basic pattern. Cut sections of fruits or vegetables or seeds such as poppy seed heads can be adapted to form interesting motifs for design.

Those who live in towns have a less obvious, but entirely different range of inspirational sources. Here are museums rich with pattern ideas in many forms,

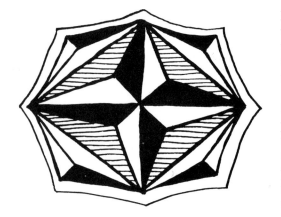

1 Repetitive motifs

from ceramic tiles and plates, hand-woven materials and tapestries (the borders of these have fascinating small motifs) to early wall papers, primitive jewellery and folk designs on various domestic objects. The Victoria and Albert Museum in South Kensington, London, not only has an excellent textile library, covering designs of all periods, but a very comprehensive art library which includes all aspects of mosaics, including design. It is well worth a visit.

To stimulate the imagination, pay a visit to your local junk yard or the back of a working garage, where design in a geometric form can be found in plenty among the old cogs, wheels, gear springs, gaskets, broken sections of old bits of machinery or furniture. In chapter V some of these objects are shown in use as impressed patterns on ceramic tesserae, but they can also be used as whole units in a geometric design for such projects as pebble pavements or mosaic tiles (1). Try and find designs from the kind of things which are around you and interest you in your everyday life.

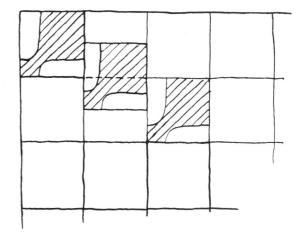

Symbols are a useful source of pattern. Various emblems, old guild seals, zodiac and heraldic emblems and Christian symbols can be translated into simple line form, enriched with added design or combined into a more intricate pattern as serves your purpose.

When outside sources from the material world fail to inspire, there are other methods by which you can create design units and shapes and by moving these around in different formations, find a pattern to your purpose. One such method is to cut a pile of white or coloured paper squares, average size 50 mm × 50 mm (2 in. × 2 in.) or 75 mm × 75 mm (3 in. × 3 in.). Taking a thick crayon, chalk or felt pen, draw some simple forms—diamonds, crescents, triangles, half squares or spiral squares and curves. Look at the varied motifs on Greek and Roman pavements and you will find ingenious versatility. Draw or trace some of these and experiment with different placings, join them together or half drop them (1). Explore the interconnecting of motifs on different backgrounds. The best approach is, in fact, to play around with the material you have in hand, every type of tessera having different qualities which must be considered when arranging a pattern face. The tesserae have a fascination which makes them irresistible both to young and old, the twinkling iridescence of their colours and the variety of their textures create the desire to handle them and move them about into groups of colour and shape and it is by doing just this that the feeling for mosaic design will gradually emerge and with it an understanding of

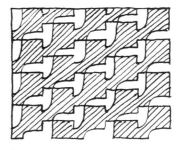

2 Half-drop motif

3(a) Graeco-Roman

its qualities and limitations.

When working with smalti or other small-scale tesserae, a carefully considered dark-light pattern must be combined with a broad treatment in the simple areas or a pepper and salt mosaic will result. This, unfortunately, is only too easy to achieve.

The practical method of learning the qualities of the medium is to roll out an area of modelling clay or plasticine, select a limited range of coloured tesserae and try out various placings of them on the clay. The advantage of this method is that they do not slip about, but are easily removable. Alternatively they may be laid out on a drawing board and moved around like pawns. Do sections in rectangles, triangles, curves, lay some of them flat and stand others sideways or angle them slightly. Keep the colour areas simple by using variations of one colour over an area, occasionally breaking into it with another colour to keep the surface alive.

All this time you will be learning about texture and pattern as well as colour management and you might well find you prefer to leave certain areas in blank clay to form their own part in the design. These sections are sometimes called negative pattern. The use of them is clearly shown in the slab glass mosaics where the concrete between the glass chunks forms an integral part of the design (see chapter VI).

Different problems can arise with differing materials. When working with ceramics which are glazed on only one side you can get light reflection by tilting them slightly, but this is also very dependent on the surface texture of the tesserae. Commercial ceramic tesserae will probably be smooth and shiny, but the ones made by yourself can have their surface enlivened by pattern treatment which will reflect and scintillate with colour.

When using natural materials, such as stones, pebbles, shells, seeds, beans, tree bark and wood, the nature of the material will often suggest the design. The markings on wood grain or the worm-eaten lines on bark may well indicate a pattern form for the mosaic. Small shapes and more involved patterns are obviously better avoided in large-scale material and often the negative areas play their part in forming the overall design in this kind of mosaic. This is certainly applicable when using sections of bark, stones and rocks and large-scale ceramic tesserae.

These ideas apply to designing of an abstract nature, which merely means an arrangement of shapes and lines to form a balanced pattern which is pleasing

to the eye. Abstract design can apply to all types of mosaics, but is especially suitable for such things as pavement units set between larger stones or concrete slabs, background walls of bathroom or patio, or smaller things like coffee tables or decorative tiles. An ordered abstract design of a wood mosaic is illustrated in chapter IX.

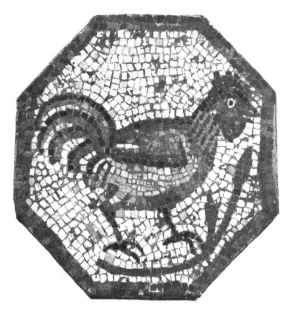

3(b) Graeco-Roman

FIGURATIVE DESIGNING

For the figurative type of design where the medium is usually smaller-scale tesserae such as smalti, cut ceramics, commercial vitreous or seeds, the array of subjects is very wide indeed and the only deterrent may be lack of skill in translating forms from the natural world into terms of mosaic. This demands many compromises and some little experience in the fundamentals of drawing, the ability to leave out all but the most significant lines and to translate the areas of form and colour into flat pattern. It is by no means as difficult as it sounds, but though you may copy the outline of a bird or animal from a book or a picture, it must be remembered that the inner forms should be simplified into a linear design of a scale suitable to the tesserae you are using.

Almost any subject may be attempted in mosaic, from the simple rhythmic forms of plants, birds, fishes or animals to a portrait of your ideal woman—although it is not suggested that you should attempt a portrait for your first mosaic! The portrayal of the natural world in mosaic has been achieved by many artists from Byzantine times and before, and even if it is impossible to look at the originals, there are many fine books in which they can be seen and studied. Observe how the many problems have been dealt with and solved, how the colour is distributed and how contour lines describe the forms. No verbal explanations can equal the close study of a work of art. (See figure 3a, b, c of figurative and symmetrical Graeco-Roman mosaics.)

Photography can be of great assistance in providing material for ideas as suggested earlier—rock formations, roofs of a town seen from a height, aerial photography, micro-photography of cells of plant life and sea life—all can be translated into abstract or figurative design.

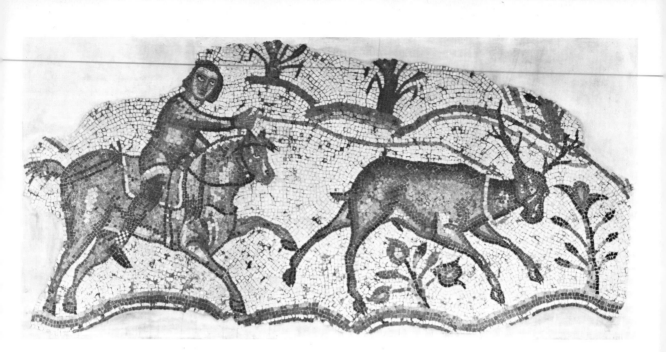

3(c) Graeco-Roman

COLOUR AND TONE

Both of these are important factors in mosaic design,
as indeed they are in any form of design, but to give
any advice on colour is probably the most difficult
thing in the world.

In choosing tesserae for your first mosaic, select
from a limited colour range, using several tones of the
same colour with one, or at the most two, contrasting
colours. If you prefer to work in strong and vivid
colour, avoid dotting the different colours about, but
keep them in small areas with only an occasional
tessera of a contrasting shade to enliven the surface.
Where you have a pre-determined situation for a
mosaic, it is helpful to choose one or two colours from
the general scheme of decoration and allow these to
dominate the design.

Working with natural material as your tesserae, the
question of colour scarcely arises, as stones, pebbles,
seeds, barks, etc., all have a natural monochromatic
affinity, but when they are mixed with tile or ceramic it
is better that the colour of the latter is of natural
origin, (i.e. earth colours such as terracotta, yellow
ochre, browns, muted greens and blues) and acid and
more primary colour strictly avoided. Use varying

tones of the same colour as much as possible rather than areas of exactly the same shade of colour.

Colour can, of course, be naturalistic or formalized—that is, the design can follow the natural colour of the object portrayed, such as a brown and red robin, or it can be formalized to the extent of designing the bird in blue or plain black to harmonize with a formal contrasting background. Colour need have no relation to reality for designing purposes unless you wish it to have.

The quality of colour in different types of tesserae varies a great deal and for this reason it is often better to use a mixture of several surfaces to achieve a lively mosaic. The vitreous colours are the least subtle, though amongst the wide range of rather primary shades there are also quite a few mid tints that will combine successfully with anything.

Italian smalti have the finest selection of colours obtainable: they come in many beautiful tints and half tones as well as brilliant, glowing reds, yellows, greens, blues, golds and silver, all possessing a richness of depth that is unequalled in any other form of tessera.

Tesserae cut from sheets of stained glass have a special quality, but their beauty can be seen to the best advantage when they have a backing to bring out the rich, translucent colour. Gold, silver or aluminium may be sprayed on from a small aerosol can or the tesserae can be set direct onto white mortar. A completely translucent mosaic, like a stained glass window, has no backing but is glued straight onto a large sheet of glass, clear or tinted as preferred.

TEXTURE AND REFLECTION

These should be considered of primary importance in a good mosaic. In the heavier natural materials like wood, bark and stones, reflection is absent and the part played by texture is even more important. The placing of stone beside stone, flat, sideways, upended, ridged by small pebbles perhaps; or again tesserae of the smalti variety, bevelled faces, lines and areas of upended or side-placed smalti, all make their contribution towards a surface of shimmering reflection. The home-made ceramics with their faces embossed with various texture patterns to break and reflect light into a myriad of coloured facets, make of a mosaic a living thing with ever-changing aspects from each line of vision.

Contrasting texture, by placing a matt earthenware

13

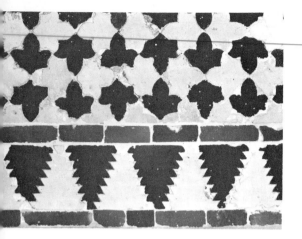

4 Alhambra tiles—border and repeat motifs

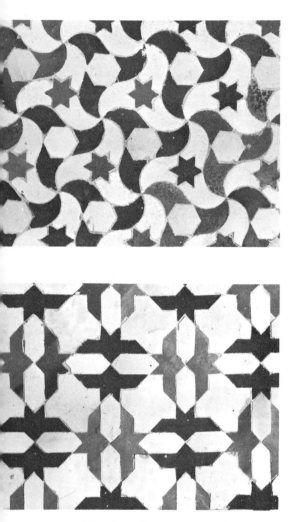

Alhambra tiles—repeat motifs

tessera beside a glittering glazed one, is a treatment that should be exploited.

Larger natural material, sections of different toned and grained woods and barks, should bring a feeling for texture into full play. Many kinds of barks and wood should be collected with as varied surfaces as possible, seeds with wrinkled and pitted skins and the glossy purple-skinned beans to combine with lichen green bark or the rich chocolate glow of coffee beans. Combining rough with smooth is usually very successful (see chapter VII).

FORM AND REPETITION

The organization of shapes and forms into a repetitive pattern is one of the earliest manifestations of designing and can be seen in nearly all primitive art. Some of its most lively examples today can be seen in the woven pulp tapa cloths from the Pacific Islands, and from Javanese and African carving and weaving. All these show repetition in its simplest form and the message is clear to read.

A retrospective journey through civilization brings an awareness of the importance of pattern in ancient Greece and Rome, whereby a form, which may in itself, be quite insignificant, is repeated to become a rich design, still in use today. The Byzantine and Moorish periods have also left an indelible mark in this field, as the illustrations of the Alhambra tiles will reveal (4), and from all these may be seen how the force of design is accentuated when a motif is repeated, reversed, turned and repeated in reverse. The dark-on-light and light-on-dark repeats contribute largely to this type of pattern, combined with the negative spaces left between the motifs.

The understanding of this element in design is an essential factor in pavement, patio or courtyard mosaics. Study the sets of repetitive motifs in the illustrations and notice how many variations can be worked out from them (1). Countless examples will be discovered and a stimulating lesson in design will have been learnt. (See figure 5, which is a plaster model of cubes and circles in concave and convex pattern.)

There is a constant need to retreat and observe the forms and shapes from a distance, or from above, if possible, especially where a floor or pavement or any large-scale mosaic is the subject. It is sometimes possible to lay the designed cartoon on a flat surface out of doors and view it from an upstairs window, or to place it on the floor of the hall and look at it from

the top of the stairs. Even standing on a table or the top of a ladder is invaluable for viewing a mosaic objectively and forming an assessment of the repetitive pattern values, and, indeed, its whole strength as a design.

Contrast, another factor which applies to all designing, is the means by which the dark-light balance in a pattern is brought about; the principles of it should be appreciated and understood by the mosaic artist.

The plainest example of contrast is probably the chess board and the many variations of alternating light and dark seen in primitive weaving, batik printing, Greek and Roman pavements, as well as many modern printed fabrics.

Practical ways of bringing about contrast in mosaics are as follows: The use of a different toned grout is sometimes sufficient to explain the main outline of a shape, and where cracks are left between one form and another the demarcation may be sufficiently shown. A strong change of tone will bring about contrasted form just as successfully as a change of colour, while the use of two different colours of the same tone value might be ineffectual.

No advice can be as valuable as working and playing with the material itself, placing and replacing areas of light and dark until the feel of the right depth of contrast arrives.

FUNCTION, DIMENSION AND SCALE

The above factors are closely interrelated. Dimension and scale are more dependent upon the kind of mosaic required, and its situation, than are some of the other facts already referred to; though a unification of all of them is the obvious ideal.

To give an exaggerated example of this principle in practice: envisage a design of a small fish motif as a decorative tile and then the same design in the same ratio on the wall of a large patio. A monster of horror would probably result, out of all proportion to its situation and surroundings, while the fish on a small tile for a fireplace surround would be in a scale harmonious with its setting.

The subject chosen, abstract, figurative or merely pattern, depends directly on its relationship to the size of the tesserae and to the overall size of the mosaic. To use 25 mm (1 in.) tesserae in a mosaic of 100 mm × 100 mm (4 in. × 4 in.) is clearly impossible unless an extremely simple motif of geometric origin is made.

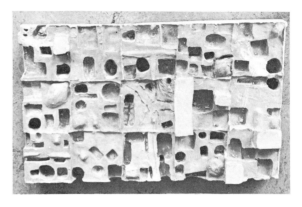

5 Concave-convex design in plaster

All this may seem too obvious to stress, but it is all too common to find a student confronted with an array of large, chunky tesserae, preparing to design a head or a figure in naturalistic proportions where certain concessions to realism must be made but which will be difficult to realize with such clumsy material. The medium chosen must always be in scale with the projected subject.

Rocks, stone and bark are best used on fairly large-scale projects where their rough texture and rather massive nature is seen at its best set in thick ciment fondu or ordinary concrete, the mortar forming its part of the design with its negative spaces.

A random design (i.e. the type of design in which the tesserae are moved about in a haphazard manner until a balanced pattern results) is the best for this kind of mosaic, and one of the most successful I have ever seen was an enormous head of a bull done by a first-year art student. The materials used were large sections of broken tiles, flower pots, slates and a few specially fired ceramic tesserae that were shaped to form certain areas of the head and neck, but they were perfect in scale for the subject and size of the work.

Practical requirements must be remembered when designing for a specific purpose. Flat non-porous tesserae should be used when the surface will need frequent cleaning or has to stand up to footsteps. Common sense should prevail here.

Outdoor projects will demand a different treatment as well as another technique, weather-proof tesserae and a mortar that is both water and frost proof. Pavements that are in constant hard use should be laid reasonably flat although it is quite common to lay pebbles sideways, packed closely together, as they bed down into the concrete better this way and can have flat paving units between each section. Avoid such fragile material as glazed ceramics, shells or thin glass (this always looks wrong out of doors).

Small seeds, beans, etc., are ideal materials for small-scale decorative panels, and although they lend themselves well to pattern designs they are also very suitable for subject mosaics, using such forms as a fish, a bird, a reptile, a butterfly, the head of a small animal or indeed anything of a scale to fit comfortably into the area of the panel.

Some will prefer to find subjects from things in everyday use or more conventional motifs.

METHODS AND PROBLEMS IN DESIGNING

How actually to begin a mosaic is often a problem. There may be several approaches but some rules are common to all of them. Some basic decisions must be made. What is the mosaic to be for—of purely decorative or practical use? Secondly, where is it to be situated? A harmonious relationship with the surroundings must be considered, and this will also dictate the type of tesserae to be used—an outdoor site would require different material from an interior one, both from the aesthetic and durability point of view. When these decisions have been made you can decide on suitable tesserae.

The initial approach for a beginner should take the form of something in a simple rectangular nature. Try designing a tile for the first attempt, making a pattern of some sort of abstract or geometric shapes, or copy one of the Roman pavimental designs, restricting it to two or three colours as was done in the black and white Roman period. If you plan to cover a small area of wall, such as a surround to a bath, decide on a motif that will repeat well within variations. If, on the other hand, you want to attempt a larger project for a specific site—such as a pictorial mural, then the design must be drawn up beforehand and enlarged to the actual size required by squaring out a cartoon to scale (see figure 7 for diagram of enlarging cartoon). The full size cartoon should be placed in situ and carefully considered before the actual mosaic is started.

When the reverse method is used, (see chapter IV) several preliminary tests should be made before the unit sections are glued finally with tesserae in readiness to be applied to the mortar base.

If you use the indirect method, the tesserae must be selected and tried out in very much the same way, but are then left in their final positions on the cartoon before being placed individually onto the prepared mortar bed *in situ*. These techniques are described in detail in chapters III and IV.

At this stage, while the tesserae are being moved about and positioned, the effects of differing textures should be observed, as this is just as important as colour in the finished mosaic. Try out the effect of the same colour in different types of tesserae—for example, a blue in smalti, stained glass, ceramic tile used right way up and in reverse, or encaustic tile.

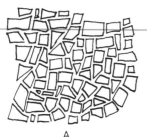

A

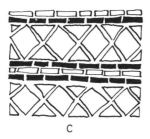

B

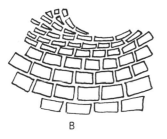

C

METHOD OF LAYING TESSERAE

The contour line—the line of direction taken by the tesserae in describing the form, is another factor in their design potential.

They can be laid in many ways: (A) placed in haphazard fashion or (B) following the contour lines of the form, (C) used as an integral part of the pattern or (D) placed in a rectilinear formation as bricks are laid. Various other possibilities will arise as you work. Different sized tesserae contribute to the liveliness of the design. See figure 6 for ways of laying tesserae.

The method used for laying the tesserae is dependent firstly on the kind of design—whether it is a figurative subject, a random type of design or a pattern—and secondly on the size of the mosaic and the type of tesserae you want to use. Look at the various examples shown in the different chapters and observe the many approaches to this problem and how widely the solution differs according to the material used.

The use of negative space, as discussed earlier, forms its part in the contour pattern, sometimes by the cracks left between the mortar following the lines of direction, while sometimes the use of a dark coloured grout has the effect of throwing the lighter toned tesserae areas into a stronger relief.

When starting your first mosaic, it is good advice to limit the materials used to those from one source, mixing them with other media only when you have gained more experience.

A METHOD OF ENLARGING A SMALL SKETCH TO A WORKING SIZE CARTOON

It is essential that the final size shall be in the same proportion as the sketch. The following method shows how to do this without any complicated mathematics or measuring.

In diagram 7 the sketch is assumed to be the rectangle ABCD on the bottom left hand corner. The enlarged size is the rectangle BGFH, the enlargement being shown in dotted lines. All you have to do is to draw a diagonal through the sketch from point B to point D and extend it to point F, which will be the diagonal of the finished project. You then extend the base line BC to a point H which is cut by a vertical dropped from point F. Next draw the line BA to a

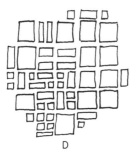

D

6 Ways of laying tesserae

point (G) which is again an exact horizontal from point F. You then have a rectangle in exact proportions to your sketch, always assuming that your sketch has been outlined as a perfect rectangle. You next divide the sketch, first in halves and then in quarters and do the same on the full-scale one. You can go on dividing up into as many squares as you like, providing both rectangles get the same treatment. These small squares will enable you to copy your design very easily, by using the numbers which correspond on each rectangle.

On a large scale project use a felt pen or a badger brush and ink to ensure that the outline will be bold and clear. If it has to be traced onto a working surface or onto another board, use carbons sellotaped together to the required size and re-draw the lines more strongly on removal of the carbons.

In random designing it will probably be necessary merely to lay out a provisional grouping of the material, shifting pieces about until a balanced mosaic falls into place. It is them transferred from the designing board to its final placing, bit by bit.

In the various examples which come under different chapter headings, individual designs are discussed in more detail than is possible here.

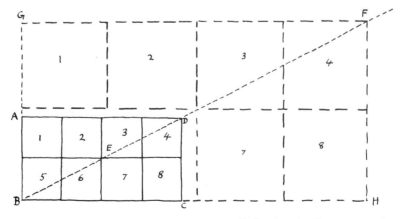

7 Enlarging sketch to cartoon size

Workplace, Equipment and Materials II

It seems obvious to start a book on mosaic making with some ideas on *where* to make them, before embarking on *how* to make them and becoming submerged in the approach to the various techniques. Most people will have to make do with the limited space that can be made available in the house and this will probably be adequate if a large work bench or stout table can be provided. Generally this is better made at a height for standing, as a great deal of work involves moving about; and bending over the mosaic from a height can be a backbreaking affair. For the times when you can sit down, or when children want to work, high stools can be provided. This bench should be as near the source of daylight as possible, avoiding it coming from such an angle as to cause a disturbing reflection from certain types of tesserae—glazed ceramics or glittering stained glass could do this. Direct sunlight is to be avoided.

If artificial light is to be used, as it must be for the many people who will work at night, a diffused source coming from a light strip is the best form of illumination, as it casts no shadows. It is now possible to buy colour-balanced fluorescent strip lighting, (or mix with tungsten lighting in the proportions of 3 fluorescent to 1 tungsten) and this is a great assistance when choosing and matching colours.

A large cupboard, or failing this ample shelf space, is essential for keeping the jars of tesserae (8 and 9) the tools, cement, glues, grouts and general equipment. If these have to be kept out of doors, they should be in a dry frost-proof shed.

8 Jars of tesserae

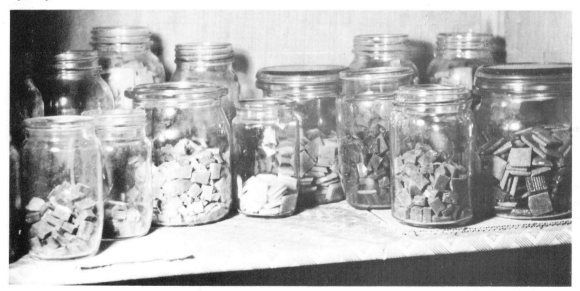

The availability of a sink and running water is very important, especially when you wish to make your own mortars, or work with home-made ceramics. When a special room or an outside shed or a barn can be made available for a studio, the possibilities are much greater and more provision both for working and equipment can be considered.

A suggested plan of a good layout for this workroom is shown (10) but the average person will obviously have to modify this considerably depending on the amount of space available and the amount that can be spent.

The south wall of the workroom could be used for designing and hanging the cartoons. A covering board of some type is needed for attaching drawings, sketches and reproductions to provide inspiration, or the actual objects themselves may be affixed on this such as seedpods, bark sections, skeleton leaves, cog wheels and various natural and mechanical forms.

The east wall may be lined with storage shelves for jars of tesserae, pebbles, china or pottery fragments or any material that can be used for mosaic making.

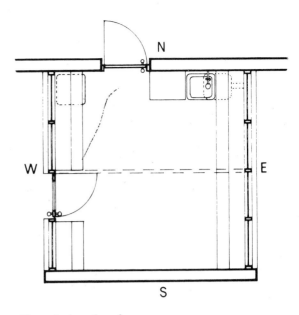

10 Ground plan of workroom

9 Storage shelf

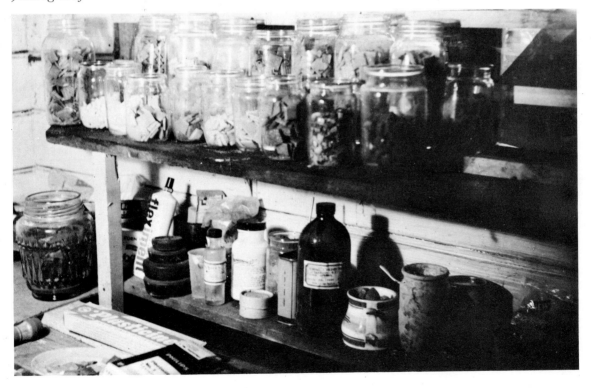

—*west wall*

—*south wall*

11 Elevation of workroom

These should be at eye level or above, with a bench beneath for the general sorting into separate dishes—a collection of odd saucers provides useful containers. Below this, place the racks for storing cartoon paper, tracing paper and lining paper, (for backing cement panels as described in chapter IV), and for general rough work. Stained glass could be stored here where it can be pulled out easily for choosing colours.

The north wall should house the heavy duty work bench with a pottery sink in a convenient position. The shelves above should take the smaller containers for glue, size, other adhesives, mortar colorants, etc., while racks and hooks should be provided for carpentry tools, mortar and general equipment. If the workshop joins your dwelling house, the communicating door could be set in this wall and while cutting down some of the available wall space, could still provide storage for frame-making materials and a bench. Storage cupboards beneath would take cement, lime, sand, expanded metal mesh, etc. To make a ceramic mural on a large scale, you will have to provide storage for the clay, glazes, slips, grog, pottery equipment and tools and a small kiln. This will be discussed under the section dealing with ceramics and glass fusing. Two tables are quite essential, a large heavy one on rollers for constructing the mosaic and a smaller table or trolley for holding the containers of tesserae and any other equipment in current use.

On the west side of the room the outer door will probably be placed and the space on either side can be used for countless other storage requirements which will arise as you progress. A bookshelf for technical and reference books, or racks for wood storage would be useful here if there is sufficient space.

There are many different types of mosaics and as many technical methods of making them, most requiring different equipment, so it will simplify matters to list the tools and materials needed under the methods described. Certain basic requirements are listed below that will be used for most carpentry and cement mixing.

EQUIPMENT

Carpentry

A hammer, a saw, pliers, pincers, screwdrivers, a drill and various sized bits, a set square, a steel rule, a good selection of screws and nails. A vice is not a necessity, but very useful.

Cementing

A mixing board made from 25 mm (1 in.) deal boards joined closely by wooden battens: 75 mm × 75 mm (3 in. × 3 in.) is a good size. Alternatively a mix can also be done in a galvanized wheelbarrow (which must be *thoroughly cleaned* afterwards). Small quantities can be done in a shallow enamelled basin. Several measures are useful, a laying-on trowel, spreading knives, palette knives, grouting squeegees and large tweezers.

Clay work and glazing (13)

A roll of scrim or sacking to roll the clay on or a large plaster batt which can be purchased from a pottery firm.

Scales for measuring glaze materials. Postal scales will serve, but a pair that will measure grammes is a great advantage for accuracy with glaze ingredients.

A pestle and mortar for grinding down glazes.

Sieves, 120 mesh is the size most generally required.

Rollers for rolling out the clay. These can be wooden, but a wine bottle will serve equally well.

Several wooden battens for checking the thickness of the clay.

Knives, palette knives, badger or fitch paint brushes, small sponges for smoothing the clay surface.

In addition a large flat photographic developing-dish for holding slips and glazes is useful.

MATERIALS

Tesserae

The traditional material of the mosaic artist is the small opaque glass cube, square or slightly rectangular, collectively known as 'smalti'. Their origins and history have been discussed in the section 'Historical Background'. The finest tesserae available are still the Italian smalti, having outstanding advantages over any other type of media. A prodigious colour range of scintillating richness, combined with durability would make them the perfect medium were it not for their high cost. For centuries they have been manufactured on the little island of Murano in the Venetian Lagoon in a workshop long famous for its glass-making and have been known commercially as

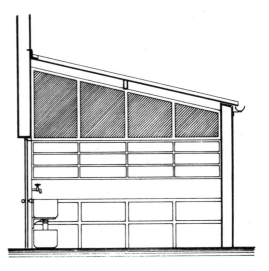

—*east wall*

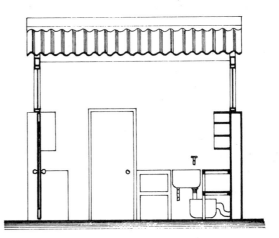

—*north wall*

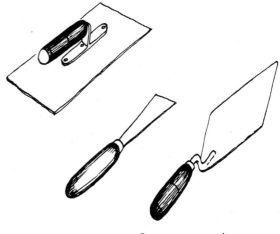

12 Some mortar equipment

Byzantine or Venetian smalti. Their composition and method of production have for long been a jealously guarded secret, but certainly ingredients such as tin oxide must have been added to the silica to achieve the opacity and translucence which is so characteristic.

The small rectangles of approximately 13 mm × 19 mm ($\frac{1}{2}$ in. × $\frac{3}{4}$ in.) are seldom cut level and this variable face gives them the reflective glitter when set on angles which is so enchanting. The colour range covers a wide spectrum and has a richness and subtlety found in no other mosaic medium. They may be combined with stained glass, ceramic or vitreous tesserae to assemble an impressive mosaic and the overall cost of the material will be considerably less. The prices of the individual colours vary widely but in general the earth colours, terra cotta, ochre, umber and burnt sienna tend to be the cheapest while some of the reds and oranges (of silenium composition), and gold and silver are the most costly.

In some of the earlier mosaics, smaller tesserae were used for a design of minute detail, usually a copy of a painting. These were 6 mm × 6 mm ($\frac{1}{4}$ in. × $\frac{1}{4}$ in.) in dimension. Even smaller ones called 'filato' (thread) were produced by cutting a small section from a long

13 Ceramic equipment

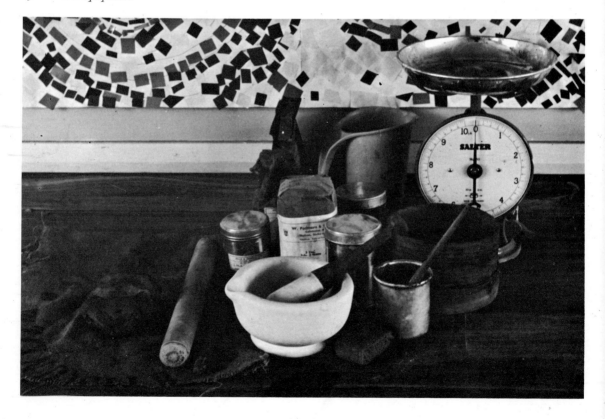

thread-like rod. A great deal of jewellery and highly detailed mosaics on small decorative articles were made in this type of material, the tesserae being arranged under a magnifying glass and set in place with tweezers. Very little of this work is done today, but some fine examples can be seen in the antique jewellery section at the Victoria and Albert Museum in London. (For those who are interested in this kind of work, a method for making the Filato Mosaics can be found in *The Art of Mosaic Making* by Jenkins and Mills, D. Van Nostrand, New Jersey, U.S.A.)

VITREOUS TESSERAE

These are of opaque glass used widely for commercial projects, coffee bars, shop fronts, kitchens, bathrooms and many decorative mosaics. They come in 19 mm ($\frac{3}{4}$ in.) squares and can be bought loose by the lb/kilo or glued to 30 cm (1 ft) square sheets of paper. The shades are inferior to the smalti and the colour range very much more limited. They are however considerably cheaper and can be cut quite easily with tile nippers into four smaller squares, narrow strips or diagonals, the glass being much thinner than the smalti. Their reflective value is rather poor.

Information regarding quantities required for general coverage is usually supplied in a manufacturer's leaflet when you order.

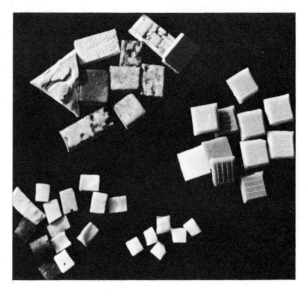

14 Three different types of tesserae

Ceramics

HOME-MADE

These are possibly some of the most interesting tesserae that can be used. They can be glossy and reflective or have a dull but glowing matt texture, depending on the glazes used. After the initial expense of the necessary equipment (which can be considerable if the cost of a kiln is included) these are about the cheapest tesserae that can be used. They can be made in any size or thickness or shape, tailored to the design in fact; and the colours can be of your own choosing, dependent of course on your success with the glazes.

The method for making them is fully described in chapter V, and the necessary equipment is listed. Suppliers for materials can be found in the list at the end of the book. The type of kiln to use is described and illustrated in figure 15 although a shelf in a larger kiln can be used, of course.

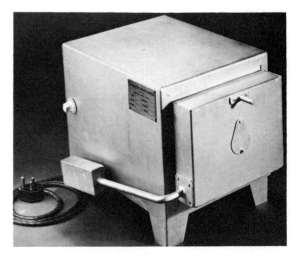

15 Ceramic kiln (Podmore's)

16 Broken china

Commercial ceramics, usually in the form of tiles, are either glazed or encaustic. In the case of the former the glaze is laid on the pre-fired (biscuited) clay and the colour, obtained by oxides and dependent on the temperature of the firing, is on the surface only. Tiles are brighter and more diverse in colour but are not proof against the weather and are unsuitable for outdoor conditions. Small varieties are obtainable, but the most common size is 102 mm × 102 mm (4 in. × 4 in.) which can be re-shaped by scoring a line and then cutting with tile nippers. Glazed porcelain tiles originating from Japan come in a variety of shapes; odd or geometric forms are supplied ready glued onto a backing sheet which must be wetted and soaked off after applying the mosaic to the mortar and allowing it to set. Encaustic tiles, which are more limited in colour range, are practically impervious to weather conditions and are ideal for outdoor use. Most of the early Roman pavements were made either of these or of natural stone. In the manufacture of encaustic tiles, the colouring is dictated by the pigment mixed with the clay, or the clay's normal colour, and therefore the tile's colour, being solid throughout, is very durable indeed.

The colours, however, are earth colours, whether made from natural clay or with oxides, so the tones are dull and subdued—browns, greys, terracotta (red earth), yellow ochres. They can be combined very attractively with pebbles and stones, having a close relationship in their colour and texture.

Other ceramic materials of more humble origin are broken flowerpot pieces, broken china collected by yourself and your friends (16).

Incidentally, one of the most pleasant little paved patios I have seen was made by an old lady who had collected her breakages of a lifetime and set them in a little circular pavement outside her cottage door. The china bits had been selected rather carefully, blue willow-pattern predominating, and an original spiral design had been used relating the blues and greys of the Wedgwood with the other colours and patterns to form circles. It is unfortunate that no photograph was ever taken of this.

Glass

Although both smalti and vitreous tesserae come under the heading of glass, stained glass and clear glass and slab glass is also used in mosaic making. The

materials and equipment will be listed in the technique section.

STAINED GLASS

This can be bought in sheets from stained glass firms and can often be bought as offcuts, bits and pieces that are too small for the use of stained glass artists. Various qualities and thicknesses of the glass are available and almost all will serve for the mosaic artist, although some are very much harder or more brittle than others. The 'flashed' (colour fused on to one side only) is the hardest and should be cut only on the unflashed side. Colourless glass can be backed with colour or affixed to stained sections. Glass filaments can sometimes be obtained or cut.

The tesserae made from stained glass can be used alone on a white base so that the colour glows, or it can be mixed with other tesserae where all except the very pale colours read as black.

SLAB GLASS

This glass is made in thick slabs of an average size of 203 mm × 305 mm × 25 mm (8 in. × 12 in. × 1 in.) (17). It has a wide range of colours and for large orders can be supplied in any shade required. A great number of artists, however, buy the clear glass and glue stained glass over this to make the colour required, using a transparent adhesive. This reduces the cost of the selenium shades, which are very expensive, but you must accept the fact that any mosaic requiring slab glass in large quantities will be very costly. Used with a concrete base as shown (18) a relatively small amount of glass is needed and the concrete plays an important part in the design.

The slab glass mosaic is usually designed over a light box, illuminated from below with a strip light. When the design is finally determined it is transferred to a cartoon for the cementing. A full description of a mosaic done by this process is to be found in chapter VI.

BOTTLE GLASS

This can be collected either on the beaches or at home. The seashore glass is generally worn, frosted and fragmented due to the action of the breaking waves and should be used in this natural form. Wine bottles or interesting glass containers must be broken into smaller sections carefully. Instructions regarding the treatment and use of this type of glass are given in chapter VI.

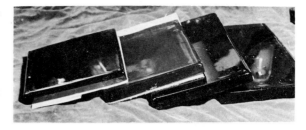
17 Slab glass

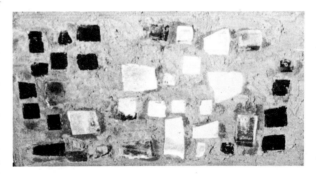
18 Slab glass panel

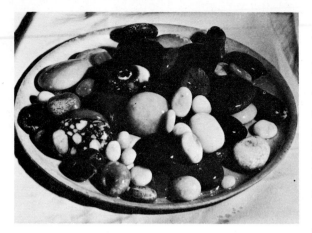

19 Tray of mosaic pebbles

The fusing of both the stained and bottle glass in a kiln is also fully described in chapter VI.

Pebbles, stones, flints and fossils

These are the basic materials for some of the most attractive mosaics. Those who live in cities are generally able to buy these from sand and gravel merchants or garden suppliers, but for the average person the pleasures of collecting these at the seaside or at the local gravel pits is incomparably more exciting and rewarding (19).

Searching and finding on beaches and in quarries gives a purpose to expeditions and all the family, down to the smallest child, can join in.

If you want to collect systematically, you should give each member of the party a plastic bag and instructions to find a certain colour or size. Living in East Anglia I have found the coast of Norfolk a treasure ground in varieties, colours and shapes, and the East coast from Walton-on-Naze to beyond Yarmouth is equally good. All the beaches around the coast have a fine selection of pebbles and rich sources of semi-precious stones can be found in many quarries and gravel pits. Fossils also abound in many of these. The main purpose of this book is to instruct in the subject of making mosaics, so I have given only a brief survey of the rich array of pebbles and stones to be found around the coastlines, and have not touched on the areas inland where such material as slate and flints may be found. The collecting of attractive pebbles is a fascinating hobby in itself, and the question of what to do with a collection of pebbles may find the answer in making a mosaic with them.

If you live inland and in a region where there are quarries, such as Anglesea, Derbyshire, Cumbria, Wales or Cornwall, many fascinating rocks and minerals can be found, such as fluorspar, barytes, quartz (the various marbles).

Iridescent furnace slag, which is a greenish-blue and not actually a mineral, can be found in many industrial areas and in quantities around the Ironstone Valley near Much Wenlock in Shropshire.

Most large towns have a geological museum where specimens of the local rocks and stones are shown together with the sites of the quarries. Alternatively the Geological Museum in South Kensington, London, gives full coverage to the geological areas of England, Scotland and Wales, showing the quarries and types of rock outcrops in each country. The

United States of America is, of course, a much richer country in minerals and semi-precious stones, and among the best hunting grounds are California and Colorado. Here also booklets on the areas can generally be obtained quite easily. Australia also is magnificently endowed—on its great stretches of beach and in its rich mineral deposits.

The situations in which stones and pebbles may be used are many. Outdoor projects can be enlivened by them—panels set into brick or stone walls, patios, pavements, the paving of ponds, garden tables and benches. With imagination they can be used on indoor sites: mantelpiece surrounds, hearth paving, panels behind sinks or cookers, these especially in country cottages in areas where such stones and pebbles are plentiful. See the illustrations in chapter VII.

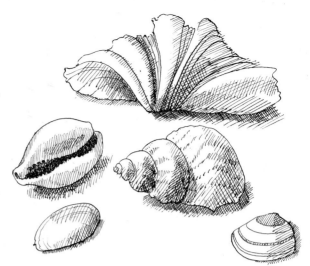

20 Five types of shells

Shells

Generally speaking, shells are not a very successful material for making mosaics. From the design standpoint they tend to look arty-crafty and it can be difficult to escape from this aspect. From the practical angle they are often too fragile and unless bedded-down well into the cement are easily broken. They seldom present a sufficiently flat surface for the use of a glue adhesive, and even when they can be successfully glued, are very often knocked off. It is possible, however, to make a purely decorative picture with them, made within a frame to hang on the wall, where they will look charming and collect a good deal of dust. Children often delight in making shell mosaics, and if allowed to experiment with this medium can be kept amused for hours.

Many varieties of shells can be used and here again the beaches are the main source of supply and the hunt a part of the pleasure. It is possible to buy shells of the exotic tropical kind from shell shops if you cannot collect your own. The more simple shapes such as oysters, mussels and cockles can be combined successfully with stones and ceramics, but the more fussy varieties are seldom successful used in this way (20).

The example illustrated (21) of a square mosaic plaque is made from black and white stones, commercial tesserae and cowrie shells. These shells are used face downwards throughout most of the design, as will be seen, but at certain points are laid on their backs—the open line down the middle making a more interesting pattern.

The following shells can be found on various

beaches in England and are all suitable for mosaics. A much wider selection can be found on warmer parts of the Atlantic coast and a few are mentioned here.

Saddle oyster	Tellin
Limpet	Venus shell
Whelk	Sand caper
Mussel (varieties)	Razor
Top (varieties)	Mail shell
Cockle	Ormer or sea ear (St Malo)
Scallop (varieties)	Winkle (varieties)
Astarte (varieties)	Wentletrap
File	Cowrie (southern Atlantic)

As no example is available to supply details of the technique, the following is a brief résumé as to the best way to use shells. After you have collected a supply for mosaic work they should be scrubbed, dried and sorted into boxes, grading into both shapes and sizes. Any type of plywood or composition board can be used as a base provided it is at least 6 mm ($\frac{1}{4}$ in.) thick or, if a large mosaic is planned, battened on the back to prevent warping.

Shells are a delicate decorative type of material to work with and this should be remembered when making the design. The lines and shapes should be kept simple and planned in areas as the shells themselves will provide pattern and texture. Colour will only be a consideration to a limited extent as the range is in tone more than in shade. Some lovely deep blues are found in the mussels and there are many pastel pinks in the scallops. However, the main shades are greys, browns, whites, creams, with various stripes and mottles that provide lively patterns.

They can be glued onto a previously coloured base with a suitable adhesive. This base may be of wood or a composition board such as chipboard. Concave shells which cannot be stuck flat should have the hollow part filled with a fine cement or filling plaster such as *Polyfilla*. Allow this to set and then apply the adhesive to this surface. Alternatively, the base itself could be a thick bed of cement or plaster into which the shells are embedded deeply enough to be held down securely. If this mix is too liquid however they will sink into it and become lost, so mix on the dry side. See list of suppliers for suitable adhesives or plaster mixes.

The framing of these shell mosaics should be considered carefully. Often a rather fussy Victorian frame becomes the ideal surround, but nearly always the frame should be deeply recessed; firstly because

the 'looking into' feeling enhances the evocative quality of the shells and secondly for the more practical reason that the mosaic is less likely to be knocked and broken than it would be on a flat surface. Wide ribbon velvet glued round the frame makes a pleasing setting. A deeply recessed frame can also be glazed, as protection against dust.

Seeds, beans, bark and other natural objects

These materials are very popular with children for work in schools and also as a home occupation. In country areas the seeds, beans or indeed any natural objects that take the eye can be collected over the summer and into the autumn, dried, baked and stored, or used at once if inspiration is there. People living in towns will find a surprising variety in the everyday beans and pulses used for cooking, and the continental

21 Shell mosaic plaque

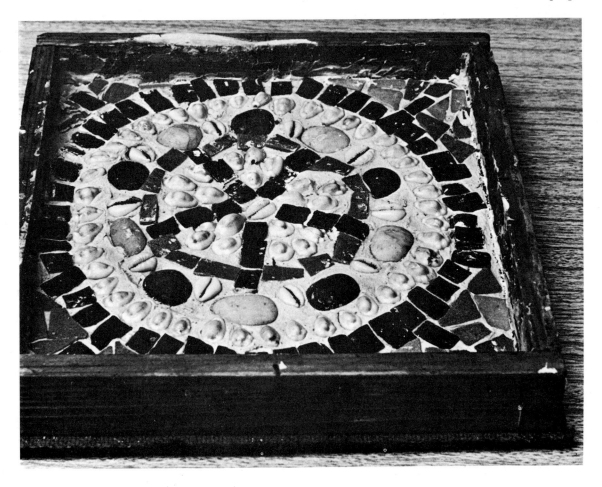

delicatessen will probably show many more un-familiar types. If you live in London, Soho is the place to visit.

As a material they are cheap to buy and free for the finding in the country, and rambles in lanes, on heaths and moors can be enriched if your eye is alert for useful material for your mosaics. Many trees have seeds and pods as well as bark in a great range of hues and textures. The plants in your garden, both vegetables and flowers, will make their contribution.

In chapter VIII a more detailed list of materials can be found together with the methods for using them, and several examples of this kind of mosaic.

Other materials

Many other materials will be discovered and used by those with perception and originality, children certainly forming the larger group in this class. Items I have seen collected by them include bones and skeletons of birds or small mammals, sections of knotted pinewood, marbles, bottle tops, beads, buttons and nuts.

Cut or torn paper, or cut sections of cotton and wool material are popular in schools to make a glued patchwork mosaic that has a very naïve charm and quality.

Wood in the form of sea-silvered driftwood, or the scraps of waste found in the pile at a timber yard or in the waste bin give other interesting materials to the mosaic artist. It is more colourful than one would imagine—purple brown, silver grey, light cream and golden tan, and can be artificially bleached or stained if the natural tone does not please. Pieces may be found that are textured with ancient worm-holes, general decay or wear from wind and sea. How to prepare and make these mosaics is also be be found in chapter IX.

The materials generally used for the many decorative objects in daily use, such as coffee tables, plant tables, serving trays, fruit plates, cheese boards, bread boards, teapot tiles, bird baths, etc., are usually the commercial tesserae or smalti.

They should always be set in a firm mortar of 3 parts sand to 1 part cement, and whether the Direct or Reverse method is used, given a final grouting to ensure that the surface will not collect dirt and can be easily cleaned. No small objects have been treated individually in this book, as they are all readily obtainable from crafts shops ready for decoration by mosaics, and the various methods are described later.

This is the oldest and at the same time the most straightforward technique, as its name suggests—the placing of the tesserae on to a base which can be either a vertical or a horizontal surface; the setting agent being a cement mortar, or alternatively some type of glue adhesive.

It has several aesthetic advantages over the Indirect or Reverse method, the outstanding one being that a more variable surface texture can be created by using different kinds of tesserae, in a wider range of sizes and shapes. The fact that these can be individually placed and tilted on different angles by hand gives a reflecting surface of light and shadow. Some may be laid flat, others sideways or angled, giving the mosaic a scintillating vitality, unsurpassed by any other method.

The skilled craftsman can combine many materials —smalti, ceramics, stained glass, or pebbles and sections of wood, all of which give a more free rein to expression than is possible by indirect means.

By use of the Reverse method this surface vitality is to a large extent lacking, a certain fresh quality is inevitably lost and a mosaic which goes beyond the limitations of a craft is usually one done by the Direct method. The advantages of the Reverse method are for the most part on the practical side, when a whole mosaic mural has to be prepared beforehand in transportable units, and this is discussed in detail in chapter IV.

The Direct method was probably the only one used during the period of high noon for the Greek and Roman mosaics, and it was not until the mid nineteenth century that the Reverse method came into popular use. However, early examples of portable prelaid units dating from Roman time are mentioned in the Historical section.

This was the sole method in use until the end of the thirteenth century when mosaics reached their finest peak and the need to mass-produce them became apparent. Well-known mosaic artists employed journeymen in their studios who would preassemble a whole mosaic by glueing it on to paper sections, and thus complete a large work under the personal supervision of the master. Under the earlier system, the journeymen had worked instead for long periods on the site, and the very act of laying each tessera individually into the mortar had lent to the mosaic that vitality which we recognize today.

Working in this technique, the tesserae were laid direct into the wet mortar. The method most com-

The Direct Method
III

monly used today is for each tessera to be glued onto the plaster or hardboard base and grouted afterwards, although the earlier method is sometimes preferable when using media of differing thicknesses. The grouting process is described on page 56 in Step 16.

The procedure for a mortar-bedded mosaic is briefly as follows: for a large scale mural, the design is sketched out and then divided into workable sized units by the enlarging method described in chapter 1. A tracing is then made of each of these units which are then transferred, one by one, to the corresponding sections marked in the damp mortar on the wall. Bear in mind that the thickness of this setting is determined by the depth in thickness of the largest tesserae. The guide lines are then retraced with a tailor's wheel or a pointed stick. The average setting time of a mortar is 2 to 3 hours, so if a detailed design involving the use of small tesserae is to be done, a smaller area of setting bed should be laid. See page 108 for the recipe for this setting bed.

The next step is to lay on the tesserae which are transferred from the original cartoon and set, one by one, along the guide lines in the mortar, pressing them well in. It is obvious that the mortar must not be too wet or the tesserae will become submerged. The amount of pressure must be carefully gauged as if it is insufficient they will fall out and if they are pushed in too far they will drown. Use tweezers to pick out any submerged tesserae and wash to clean off mortar before replacing.

On the completion of a section, wash away any surplus mortar to leave a clean edge before starting the next section. Damp the set mortar at the junction before the next lot is applied against it. This technique is very fully described on pages 37 to 41.

If a portable type of mosaic is required, as it may be in a situation where conditions are such that it is not possible to work on the site, units may be prepared beforehand, and set into the prepared wall, which is usually corbelled out to receive it. These units should not be larger than 50 mm × 50 mm (2 in. × 2 in.) as beyond this they are difficult to handle and attach to the wall. Backing boards are required which are removed when the mortar has set and metal reinforcing is an essential. Hinged frames which are also removable are an advantage. For mosaics of this size, the Reverse method is the better one to use.

These mosaic units may be used on walls or for paving sections, but if a larger mural has to be done in this method, it is advisable to consult the contractors

or builders as to the best type of wall fitting to be used, as this will be dependent on the wall surface. In some cases a hardboard backing is used for the mortar and this is fitted with heavy duty hangers at the back so that the mosaic may hang flat against the wall. The backing board *must* be water-proofed (see Water-proofing page 109) and the hangers fixed in before the mosaic is laid.

A thin layer of mortar is laid within the frames and a reinforcing wire mesh laid onto this before the actual setting bed is trowelled on. This technique is also described in example 1.

The method of gluing tesserae on to various types of backing board or prepared wall surface has become popular recently on account of the many new adhesives that have come on the market. New chemical combinations make it possible to find the perfect adhesive for every situation and condition and some of the *Unibond* and *Bondcrete* types are, as their trade name suggests, a strong bonding element for concrete. The tile cements and grouting cements which may be purchased in ready mixed packets are worth experimenting with, and for the more adventurous, some of the casting resins which may be poured over the laid-out mosaic will form a durable and impervious seal for the tesserae. They may be used for table tops or trays but their somewhat synthetic surface is rather commercial looking. When making a mosaic by either of these methods, as in the reverse method, a final grouting is usually given, except when casting resin is used and the tesserae are rough and uneven and a coarse natural surface is the deliberate intention. An illustrated example of this kind of work is shown in figure 100, page 70, of a ceramic plaque set in plastic adhesive.

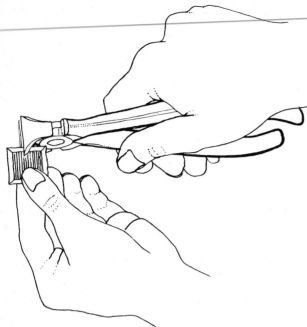

Vitreous tesserae, smalti, ceramics and tiles can all be cut with ordinary nippers, but the mosaic cutters illustrated (22) should be purchased if serious mosaic work is intended. They are adjustable to different thicknesses and produce a clean, accurate cut with a minimum of effort.

The tessera should be held in the left hand at right angles to the tool which is held in the right hand, towards the end of the handles. Close it onto the tessera and cut approximately 3 mm to 2 mm ($\frac{1}{8}$ in. to $\frac{1}{16}$ in.) over the edge. Depress with a sharp nip and the tessera should break cleanly in half as shown in figure . 22. Never push the tessera right across inside the cutter as it will be more likely to shatter into several pieces than to break cleanly. A little practice will soon bring dexterity to this simple operation. Always make certain that you have cut adequate quantities before you start to lay the tesserae, to prevent running short when working on a tricky section that is drying fast.

THE SEATED FIGURE

The first example of this technique is a decorative panel of 380 mm × 760 mm (15 in. × 30 in.) set in a cement mortar, done in three stages.

Materials (tesserae)

Smalti	Mortar
Hand-made ceramics	1 part Portland cement
Stained glass	3 parts sand
Vitreous tesserae	$\frac{1}{4}$ part hydrated lime
Tiles	$\frac{1}{8}$ part black cementone

Wood for framing
Softwood, 244 cm (8 ft) length of 25 mm × 13 mm (1 in. × $\frac{1}{2}$ in.)
Chipboard backing (later removed) 380 mm × 760 mm (15 in. × 30 in.)
Wire mesh, 25 mm × 13 mm (1 in. × $\frac{1}{2}$ in.) gauge, size 330 mm × 710 mm (13 in. × 28 in.)
Four clamps or weights
Plywood square, 13 mm × 255 mm × 255 mm ($\frac{1}{2}$ in. × 10 in. × 10 in.) (for flattening tesserae)
Wooden batten for levelling

22 Tesserae cutters and cutting

Tools

Glass cutter
Tile nipper or mosaic cutter
Small hammer
Wire clippers
Tailor's wheel (for tracing)
Mortar trowel

Basic carpentry tools for making frames

Method of working

After several preliminary sketch ideas, a design was decided on and a cartoon drawn out of a conventional type of seated figure of a scale matching the size of the panel. An important point to be remembered when designing a mosaic to fit into a given space is that the design must have the right relationship to the area.

A selection of mixed tesserae was chosen; smalti, ceramics, vitreous tesserae, tile and stained glass. The colours used were from a wide range of blues, from a dark royal to a pale eggshell, browns from deep peat to pale gold and amber, a greyish pink and a grey-white were included and where strong contrast was required, a small quantity of black.

The reverse side of some of the hand-made ceramics was used, giving the natural matt clay texture to set against the shimmering stained glass and smalti.

The main feature of this design was intended to be a contrasting pattern over smaller areas, giving an overall effect of a sampler, the tesserae being used flat in the main sections and sideways in parts such as the head where interest was to be focused.

Before the tesserae were laid on the cartoon, a second cartoon was traced out to lay later on the wet mortar.

A good supply of stained glass tesserae in various sizes was cut in readiness (see page 74 on glass cutting), but a glass cutter and some spare glass were kept in hand for cutting odd shapes as the work progressed. It was also necessary to cut the circular sections of the tiles, and the shapes for the feet. Most of the other tesserae were cut as required as the cartoon was laid out.

STEP I

The cartoon was pinned to a drawing board which was angled slightly forward by slipping blocks behind

23 Tesserae laid on pattern line

37

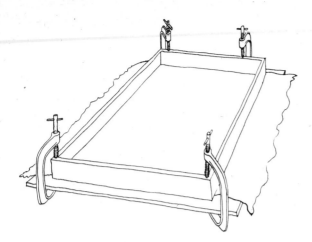

24 *Frame clamped on board*

it. The angle is for ease of work but must not be angled too steeply or the tesserae will slip down. They were tried out experimentally in several arrangements before the final plan was settled. As discussed in chapter I, this playing about with colours, different materials and placings, is an important feature in planning a mosaic.

STEP 2

The kind of tesserae, the colours and placings having been decided upon, they were now set along the lines and filled into the areas of the cartoon. It must be remembered that they must not be set closely touching each other, but a small space left between each one. The reason for this will become obvious when you start embedding them into the cement. The small amount of this which is displaced when the tesserae are pressed down, squeezes up between each one, and if no allowance is made for this it will soon be found that you have too many tesserae to fit into the frame.

In this design the tesserae were laid along the lines of the pattern rather than that of the contours as can be seen in the illustration (23) to stress the square unit motif of the sampler effect.

Regarding colour, the background was kept dark in tone by using mostly stained glass in black or a dark blue, and similar shades in vitreous tesserae, while the tones of the figure were in lighter blues and browns, the dark shades being used only when the checkerboard pattern was most in evidence.

STEP 3

The laying out of the tesserae completed, the wood frame was made, (see Framing page 109) and laid onto the chipboard backing which was covered with a sheet of oiled lining paper (any form of vegetable oil or lard will do for this, and prevents the mortar from sticking). The type of backing board used is immaterial as it will be removed when the mortar has set, provided that clamps or weights can be fitted onto each corner. The frame was now clamped on to the board (24).

STEP 4

The wire mesh was cut to fit in the frame. It must be 25 mm (1 in.) smaller all round than the framing and should be flattened as much as possible before it receives the mortar. It was left in readiness beside the frame while the mortar was mixed.

STEP 5

The laid out mosaic and the frame ready for mortaring were placed as close together as possible for the transferring of the tesserae from one to the other. In this case two tables were placed parallel to each other and the artist sat on a stool between the two.

STEP 6

The first layer of mortar was mixed in the directed proportions, but no black *Cementone* was added to this mix. It was trowelled into the prepared frame, tamped down well round the edges and in the corners and finally a wooden batten was drawn across to level to a height of about 8 mm ($\frac{1}{3}$ in.)

STEP 7

The wire mesh was laid over the bed of cement and pressed well down (25). The section of heavy plywood was placed over the top and hammered down firmly, to bed the wire mesh into place (26). Starting from the centre, it was moved all over the area of cement and hammered down in this manner. Then it was removed and the mortar left to dry for 24 hours.

STEP 8

The second mortar mix was prepared of a slightly less stiff consistency in sufficient quantity to cover one third down the frame. It is always advisable to prepare more mortar than you may need rather than to run short and have to make another mix.

STEP 9

The first layer of cement was thoroughly damped before the next mix was trowelled on to it. This, again, was well tamped down around the edges and at the corners, and after being brought up to the edges of the frame, it was again levelled off with the batten of wood.

STEP 10

The traced cartoon, which was divided into three sections, was laid over and the first section traced through onto the wet cement with the tailor's wheel. (The dampness of the cement usually moistens the paper sufficiently so that the wheel can cut through it and inscribe a clear line (27). The tracing was then removed and the traced line reinforced if necessary by incising it deeper with a sharp stick or a dental probe.

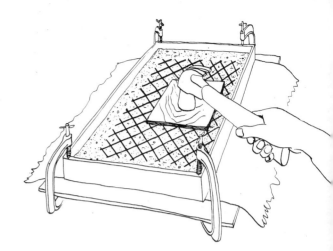

26 *Wire mesh hammered into mortar*

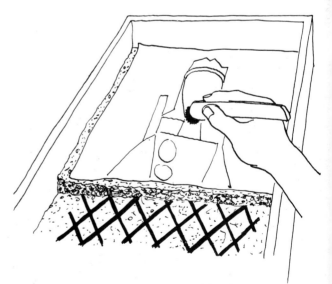

27 *Design traced through with tailor's wheel*

28 Mortar cut on pattern line

STEP 11

Transferring and embedding the tesserae now began, starting with the head section where it was important to be careful and precise. The tesserae were placed along the guide lines and gently but firmly pushed into place. Some of the larger ceramic ones, which were rather porous, had to be damped on the underside and then hammered down, care being taken not to damage the glaze. After a small area had been covered, the plywood square was placed on top and hammered all over to bed down uniformly. In some places where the tesserae were tilted or set sideways, this could not be done, of course; if, however the cement is of the right consistency they should all press into place quite easily.

STEP 12

The $\frac{1}{3}$ area was laid in just under two hours, by which time the cement was becoming appreciably harder. The final line of tesserae was not straight but followed the irregular line of the design (28). The remaining cement was cleaned off sharply at this point so that the next mix, which would be applied next day, would meet up against it as a vertical edge and not leave a thick line of cement between to show the join. Any surplus cement soiling the tesserae was wiped clean just before the mosaic was set (29).

29 Edge of mortar

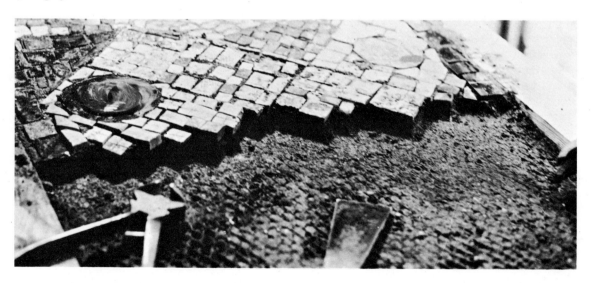

A further mix was prepared and the work continued as described. Before laying and levelling the fresh mortar, however, the edge left from the previous day was thoroughly damped and this was repeated in the final stage of cementing.

STEP 14

The mosaic was left to set, uncovered in a cool workshop for five days, after which it was removed from the frame and the oiled paper peeled off the underside. It was cleaned again, this time using a stiff nail brush and a soft cloth. This completed the work (30).

STONES AND CERAMICS SET IN ADHESIVE (31)

The second example of the technique was done in pebbles, stones and textured ceramic sections set in a bed of plastic cement which dried slowly, from three to four hours, giving ample time to lay in the tesserae. The white cement was neutralized by adding a little colouring powder. The mosaic was backed by 6 mm ($\frac{1}{4}$ in.) plywood and framed in soft wood.

It was designed in the random distribution method, by placing the various materials onto the wet mortar square and rearranging them until they composed themselves into a balanced pattern. The colours were all the muted tones found in ceramics, dull blues, greys, silver whites, set against the dark grey and cream pebbles, the matt surface of the stone contrasting rather dramatically with the gleam of the ceramic. The dark background helped with this setting.

Materials

Pebbles and stones in grey, silver white and cream
Ceramics with various impressed surface patterns

Mortar

Nic-o-Bond Thikbed $\frac{1}{4}$ litre ($\frac{1}{2}$ pint) tin
Black *Cementone*, a small part

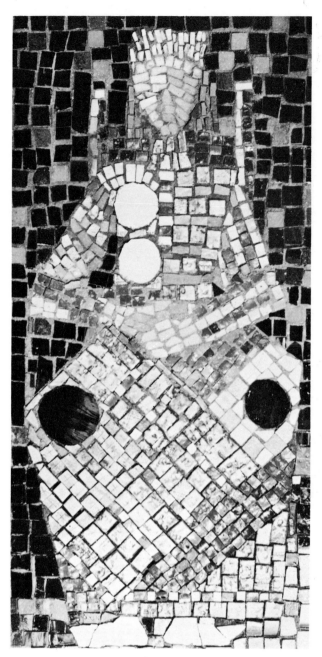

30 Completed mosaic

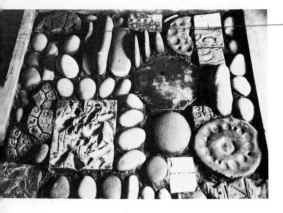

31 Ceramic and pebble plaque

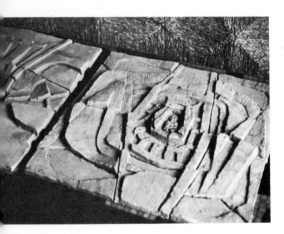

32 Sections of tiles joined to form unit

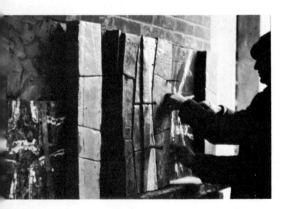

33 Setting in position

Wood

Softwood, 370 mm (4½ ft) of 50 mm × 13 mm (2 in. × ½ in.)

Plywood, 305 × 305 × 13 mm (12 × 12 × ½ in.)

Tools

Mortar tools Carpentry tools

Method of working

The technique for making this mosaic is extremely simple. The frame having been made and nailed on to the base plywood, a layer of the plastic cement *Nic-o-Bond* was trowelled on to a depth of 25 mm (1 in.). The stones and ceramics, having been placed in their final positions, were pushed into place. The stones which were set on edge on their sides, required to be bedded well down into the mortar, while the flatter ceramics were placed in more lightly and shallowly.

The mosaic was allowed three days to dry and left finally in its frame.

CERAMIC TILE MURAL
BY GEOFFREY WICKHAM ARCA

This interesting work, which I have been allowed to reproduce here, could be termed a mosaic mural although the individual units are large in scale. It does, however, show the relationship that can exist between glass and ceramic tiles, both glazed and matt, and exemplifies some of the techniques discussed in this book.

The mural was designed for the entrance of an office building when approaching from the road beneath the building. It runs through the glazed walls and may be appreciated from both inside and out. Composed of tiles set in relief on a brick wall, it consists of about half black commercial floor tiles with white and translucent decoration fired on to them. The relief is further extended by deeper terracotta tiles, set out where necessary on brickwork that had been corbelled out for that purpose when the wall had been built.

The whole design was intended to read as a series of vertical panels, 8.2 m × 68.5 cm (27 ft × 2 ft 3 in.) on a wall of horizontally pointed bricks.

Materials

Stained glass Cement
Slab glass Sand
Black commercial floor tiles
Terracotta relief tiles

Method of working

Briefly the technique is as follows: A scale maquette was first made showing the forms, relief and colour intended, using the dark industrial tiles to act as a foil to the freely modelled relief tiles. These relief forms were of a size that could be fired (at 800°C) in a smallish kiln and the design was in part dictated by this requirement. If the illustration (32) is carefully studied, the sections composing the terracotta relief tiles can be clearly seen.

The black industrial tiles were decorated with underglaze colour and fired with a white tin glaze.

The stained glass was broken into small pieces and set in the correct position before firing. They were then fired a second time to fuse the glass in pools between the relief.

The completed tiles were delivered to the site where they were set onto the wall by a professional tiler (33) using the traditional mortar of 3 parts sand to 1 part cement.

See figures 34 and 35 for the final section and the completed mosaic.

Photographs of three further examples are given as they show in closer detail different methods of laying tesserae (36, 37, 38).

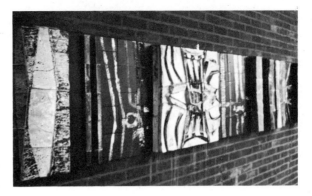

34 Final section

35 Completed mural by Geoffrey Wickham ARBS, ARCA

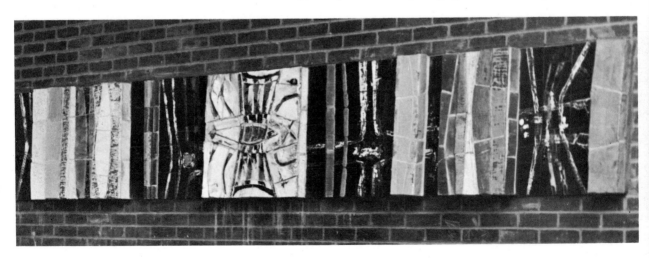

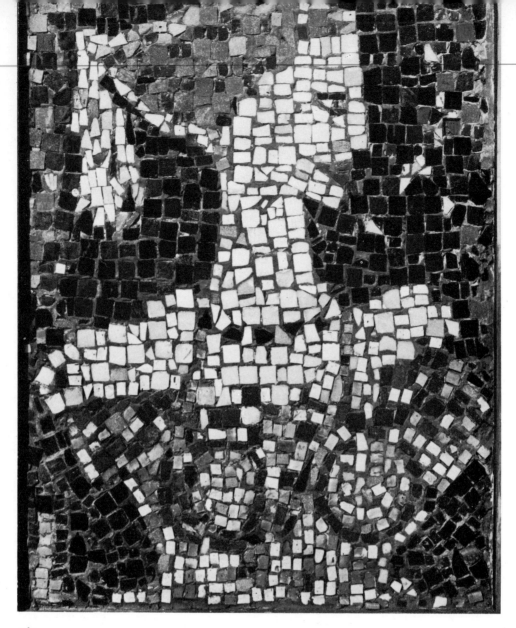

36

Head of a woman was carried out in vitreous tesserae with the exception of the necklace where golden smalti were used. The haphazard method of laying, combined with a dark coloured grout, gives a fairly lively texture to the conventionally designed head. The actual scale was three-quarters life size, so many of the tesserae could be used uncut while others were merely slit into rectangles or triangles (36). The mortar used was ciment fondu, 4 parts sand to 1 part fondu.

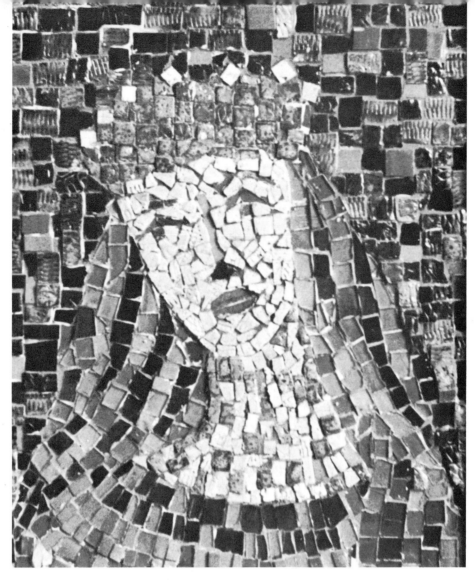

37 *Head of a queen* was made with four different types of tesserae in variations of the same shade. The crown was entirely hand-made impressed ceramics in shades of turquoise green and blue, with a few stained glass tesserae in variations of th same shade. The crown was in mixed ceramic and the face in white highly glazed ceramic, placed at random, stained glass being used for the eyes, nose and mouth. The hair and body were in stained glass tesserae with a section of smalti around the base of the figure.

The cement used was *Fixtite*, a white adhesive that may be laid in small areas at a time. The white base allowed the stained glass to record its true colours. As may be seen from fig. 37 certain areas of the tesserae were laid on the contour lines while others were laid as loose chippings.

Abstract design (38)

This was carried out almost entirely in smalti, with only a few sections in impressed ceramics, all being laid along the contour lines of the design. It was set into *Fixtite* which was laid in small areas at a time, as in the *Head of the Queen* mosaic (37).

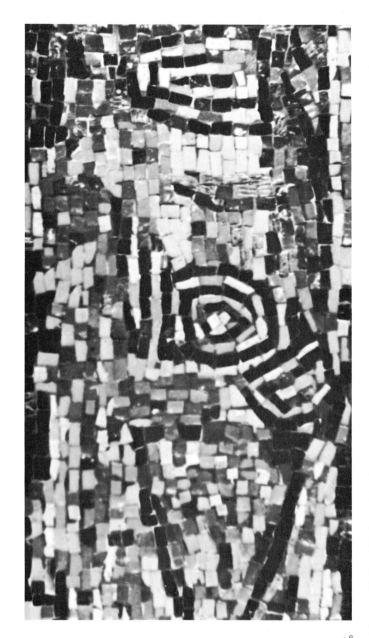

38

This method is so named because the technique consists in reversing the tesserae by first glueing them back to front onto the paper cartoon sketch, then reversing it and pressing the tesserae-backed paper onto the wet mortar base. When the cement has set the paper backing is damped and peeled off, revealing the tesserae right side uppermost. Grouting is usually necessary to fill in the cracks and space must be allowed for this infilling when placing the tesserae onto the cartoon. A gap of 3 mm ($\frac{1}{8}$ in.) is an average space but this will depend on the size of the tesserae.

The following points are worth remembering when you use this method. Take care that each tesserae has a flat face contact with the backing paper otherwise it will not adhere properly and may become dislodged during the fixing operation and sink under the mortar bed. Smalti are more difficult to deal with than the vitreous material. Try and cut the junctions between each unit section irregularly rather than in tidy rectangles so that the joins will be less noticeable—rather as you would cut a jigsaw.

The general procedure is as follows: the design is prepared and drawn onto the squared paper (39) and a tracing is made of this. When a large scale project is intended, a tracing is always necessary. The tesserae are now laid out experimentally on the cartoon (40), and colours are chosen and contour lines arranged in various formations until they are satisfactory. When this stage is completed and all the tesserae laid out, the tracing of the cartoon is placed beside it (41) and the transferring of the tesserae can begin. Each piece must be lifted out, spread with paste and placed on the tracing in exactly the same position, and the same way up as it was arranged on the cartoon (42). At this point it must be remembered that 2 mm ($\frac{1}{12}$ in.) space must be left between each tesserae for the grouting. The glue must now be left to dry for 24 hours.

The sections must now be separated (43); some will be squares and some must follow the contour lines as dictated by the design. In the Reverse method it is all too easy to become confused when setting these sections into the wet mortar, and it is helpful to prepare a numbered key, remembering particularly that the image will be reversed and the numbers will be the other way round.

The sections themselves are now numbered on the back and stacked for transportation to the site (46).

In the case of a large mural it is wise to have the wall prepared and the setting bed laid by a professional plasterer, as a vertical surface can present real prob-

The Indirect or Reverse Method IV

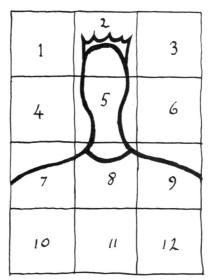

39 Squared cartoon

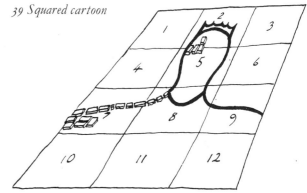

40 Tesserae laid out experimentally

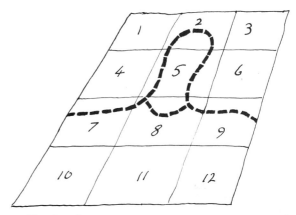

41 Tracing of cartoon

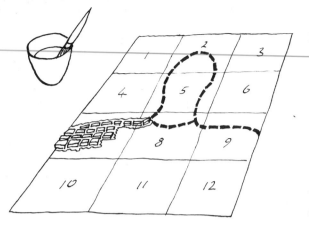

42 Gluing down tesserae

43 Sections being separated

44 Section of cement setting bed

lems if the cement is too wet and the mosaic sections slide down. Too much water can also cause the tesserae to become dislodged and drown in the setting bed. It is safer to lay an area of the setting bed for each section at a time (45), although if several assistants are available you can cover a larger area before the cement begins to harden. Some people prefer to work from the bottom upwards to avoid the sections slipping down and this is the best method if you are a beginner.

The tesserae sections are usually grouted before being laid on to the setting bed by being placed paper side down and a thin grout trowelled over them (46), filling in all the cracks, the surplus then being wiped off. (See recipe on page 108). The sections are then carefully placed in position on to the cement bed (47) paper side up, (noting as in the diagram the numbers now run from right to left) and pressed into the mortar. A flat board laid across and gently hammered is a good way of embedding the tesserae evenly.

The removal of the backing paper (48) must be done carefully when the cement is almost dry. If allowed to become too dry it will be impossible to make any small alterations or correct the position of tesserae that may have become misplaced. It will also be more difficult to remove the paper, which in any case must be thoroughly damped with a sponge before it is peeled off. If, on the other hand, the mortar is still too wet the tesserae will be displaced and the mosaic irreparably damaged.

Test the setting at one corner by peeling back a small section of the paper preferably where the tesserae are placed on a background area so that the main design lines will be undisturbed. If the right moment has been chosen, the paper should peel away easily and the setting bed should still be soft enough for minor adjustments to be made to displaced tesserae. It is difficult to give an accurate estimate of the setting time as various factors affect it—the thickness of the mix, dryness or humidity in the atmosphere, etc.—but if the paper cannot be removed easily, it should be wetted with a damp sponge.

Grouting may also be done after the whole mosaic is set in place and the cement hardened in the same way as described earlier. A wide rubber squeegee should be passed over the grout to level it and also to clean the surface. When all is completely dry and set, it must be thoroughly cleaned with a fine hard-bristled brush. A solution of muriatic acid can be used to remove any difficult cement deposits on the tesserae, but this should never be used on a coloured grout as it will

bleach out the colour.

Several points should be noted in regard to this method. First its undoubted advantages. It is obviously the one to use when a completely smooth surface is required, as for a mural in a bathroom or kitchen, a floor or a table top—surfaces that need constant cleaning. Secondly, where a large-scale project is called for, the whole scheme can be worked out in advance and then transferred to the paper sections and taken to the site. This has the distinct advantage over the Direct method where the tesserae must be set in heavy cement units to be moved, or the artist must work slowly and laboriously on the mosaic *in situ*.

The Indirect method also has several distinct disadvantages. Using the traditional technique, only tesserae of equal thickness can be used, although it is just possible to combine smalti and commercial tesserae. Angling and tilting the tesserae, which give such lively reflective surfaces, is not possible and the final mosaic is inevitably more mechanical in appearance.

In the diagrams showing the stages of this technique the irregular separating of the sections is shown (43). This is to avoid a common problem that arises when the design is not a geometric one and the junction between the sections is often too clearly visible, spoiling the unity of the design. The cutting of the sections along the contour design and sometimes dog-toothing them (28, 29) avoids the obvious break where each division occurs.

It is also important to be sure that each section is bedded down to exactly the same level as its neighbour or the completed mosaic will become a landscape of hills and dales. The division of the mosaic into sections is unnecessary for a small-scale one of 305 mm (1 ft) square or under and it is obviously wiser to gain experience on one such as this before embarking on a large mural.

46 *Stacked, numbered sections*

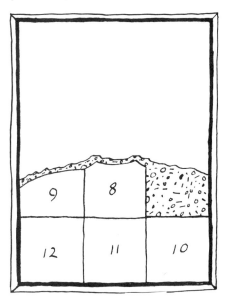

47 *Sections being laid into cement bed*

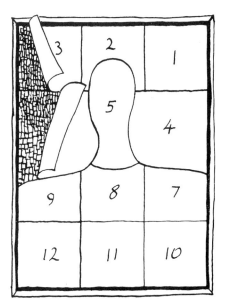

48 *Removal of backing paper*

45 *Grouting being laid over tesserae sections*

49

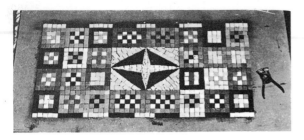

49 *Design laid out on hardboard*

A COFFEE TABLE

This shows the practical application of mosaics for objects of everyday use and the choice of a coffee table seemed to have a fairly general appeal. The procedure is straightforward and the technique a slightly simplified version of the traditional one. For a beginner the best approach is to work out a mosaic design in geometric shapes before deciding on the final surface measurements of the table, the reason for this being that if a symmetrical pattern is decided upon, vitreous tesserae laid out according to the pattern and spaced correctly will give the final measurements. It must be remembered, however, that a certain latitude must be allowed or you may find parts of the tesserae overlapping at the edges, making the fitting of a finishing frame very difficult.

Materials

Vitreous tesserae in shades of muted pinks, greys, blues, whites and blacks.

Blockboard 470 × 930 × 19 mm
(18$\frac{1}{2}$ in. × 37 in. × $\frac{3}{4}$ in.) thick
4 table legs, 380 mm (15 in.) high (any hobby shop or supplier)
Hardwood strip approx. 6 × 310 × 255 mm
($\frac{1}{4}$ in. × 1$\frac{1}{4}$ in. × 10 ft)
$\frac{1}{2}$ litre (1 pint) *Unibond* adhesive
Dunlop S 854 solution
Screws for table usually supplied with legs
Cement and fine sand (for grouting)
Strong tracing paper
Bradnails (for attaching frame)

Tools

Mosaic cutter Sponge or cloths
Hammer Mixing bowl
Spatulas for grouting and spreading (these can be cut from cardboard)

Method of designing

In the example illustrated it was decided to use a basically symmetrical pattern made up of squares rectangles with a central motif of slightly more complicated design in which the tesserae would have to be cut and fitted. This resulted in a pattern which was very easy to lay out for a large part of the area and

presented only a little more complicated work in the centre.

The colours used were variations on the shades of pinks, blues and greys, together with black and white, and these were moved about until the design took form. A good deal of black was to give a predominating feeling of contrast. The central star motif was kept intentionally loose in handling, as if it had been more precise the mosaic quality would have been lost.

50 *Table top marked out in rectangles*

Method of working

The method used here differs from the conventional one in that the tesserae were not laid down in reverse but right way up and the adhesive paper, which was pressed onto the top of them in sections, was simply lifted up with the tesserae adhering, laid onto the *Unibond*, and peeled off later.

51 *Table reversed, showing legs screwed on*

STE I
When the design was finally settled (4), with the tesserae lying *face upwards*, and properly spaced (2 mm or $\frac{1}{16}$ in. should be allowed for grouting) the area was carefully measured, allowing 6 mm ($\frac{1}{4}$ in.) extra all round.

STEP 2
The blockboard was then cut to this final size—470 mm × 930 mm ($18\frac{1}{2}$ in. × 37 in.)—and the design squares marked on it (50).

STEP 3
The legs were then screwed on (51).

STEP 4
Tracing paper squares were now cut to a unit size of 305 mm × 228 mm (12 in. × 9 in.). This covered some six squares at a time, which was the largest area of tesserae that could be transported.

STEP 5
With a spatula, the tracing paper squares were coated with the rubber adhesive (*Dunlop* S 854 solution) which has the property of remaining tacky but retaining sufficient strength to lift the units of tesserae so that they could be removed to the table top. These squares were then laid on to the sections they related to and pressed down hard. Tracing paper was used so

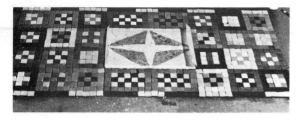

52 Tracing paper attached to central section for lifting

53 Lifting central section by holding tabs of tracing paper

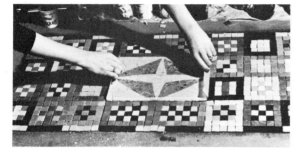

54 Laying adhesive onto section before transferring tesserae to it

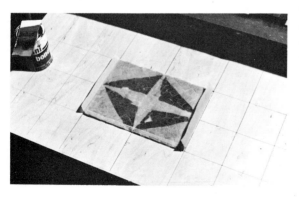

55 Central section in place on table

that the tesserae would at all times be visible through it (52) and any that had moved or fallen off could later be replaced. Small tabs of tracing paper not coated with adhesive were folded back to make a handle for easy lifting (53).

STEP 6

With another spatula the table was coated with several layers of *Unibond* adhesive up to between 3 mm ($\frac{1}{8}$ in.) and 6 mm ($\frac{1}{4}$ in.) thick, coating one section at a time.

STEP 7

Each section of the tracing paper with the tesserae attached was carefully placed in position on the *Unibond* surface of the table (54, 55) taking great care with the meeting of the junctions. The tesserae were pressed well down with a flat board which was gently hammered all over to ensure that they were all dead level.

STEP 8

The completed table was turned upside down on the floor and left overnight so that the *Unibond* would grip properly.

STEP 9

The next morning the table was uprighted and the tracing paper gently peeled off (57). Any tesserae that had not held were replaced by hand using a dab of *Unibond* on the back.

STEP 10

A grout composed of 1 part cement to 3 parts fine sand, with a little black *Cementone* added, was now mixed to a rather liquid consistency.

STEP 11

This grout was spread across the surface with a wide spatula, working well down between the cracks. In this instance two people worked, one spreading while the other wiped off the heavy layer of surplus grout (58).

STEP 12

Finally the strips of wood were tacked to the edges of the blockboard with the bradnails.

A grout (this time mixed with a small quantity of *Unibond* to give adherence to the wood) was used to fill in the space between the tesserae and the edge of the wood and this was smoothed level with the surface with a small trowel (59).

STEP 14

The whole surface was left to dry completely and then thoroughly cleaned and finally waxed and polished, and the edges of the wood painted black (60, 61).

A final point worth noting is that in a design of this nature, irregularity in spacing of the tesserae is generally an advantage in that it offsets the rather uniform nature of the design.

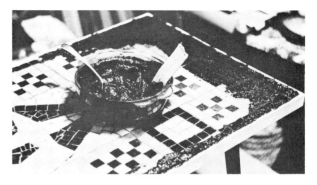

59 Grouting edges between tesserae and frame

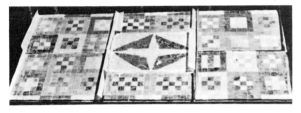

56 All sections in place on table

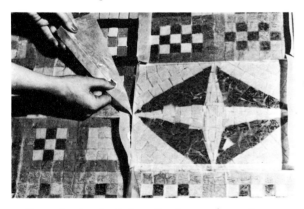

57 Removing tracing paper after tesserae have set

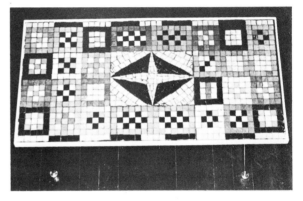

60 Table after grouting

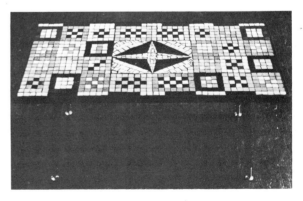

61 Finished table with edges painted black

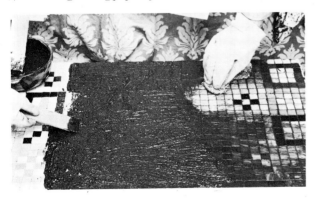

58 Grouting and cleaning

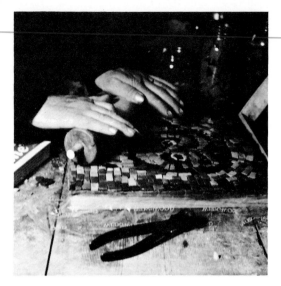

62 Rolling tesserae flat into plasticine

AN OWL MOSAIC

The design for this was adapted from a photograph in a nature magazine. It was then squared out and enlarged (method described in chapter I) on to heavyweight tracing paper.

Materials

Venetian smalti Commercial tesserae
450 gms (1 lb) plasticine
Plastic sheet 460 mm (½ yard) square
Open-mesh sacking about ½ m/yd square (clean)
60 to 80 gms (2 to 3 ozs) gum arabic
Metal mesh reinforcing (305 mm × 305 mm or 12 in. × 12 in. expanded metal 9 mm × 13 mm or ⅜ in. × ½ in. mesh)
Clamps or weights (4)
Wood for framing 1370 × 9 × 38 mm (4½ ft × ⅜ in. × 1½ in.)
Nails (50 mm or 2 in.)
Hydrated lime Portland cement
Fine sand *Cementone* (black)
Plywood baseboard 305 × 305 × 13 mm (12 in. × 12 in. × ½ in.) waterproofed
Rolling pin or bottle

Tools

Mosaic clippers Carpentry tools Mortar tools
Wire cutters (for cutting reinforcing)
Tailor's wheel (for transferring design)
A wooden batten (for smoothing and levelling)

Method of working

STEP 1

The plasticine was first softened by warming slightly (modelling clay may be used for this operation instead of the plasticine and is considerably cheaper).

STEP 2

The plasticine was divided into four and rolled into balls.

STEP 3

These were rolled uniformly flat and then cut into square units of 100 mm × 100 mm (4 in. × 4 in.) approximately 13 mm (½ in.) thick.

STEP 4

Nine of these squares were made and were then laid on the baseboard in rows of three to form the 30 cm (12 in.) square required for the mosaic. The divisions were all pressed together with the thumb and the whole was rolled out to smooth and level it, thus slightly reducing the thickness. It was then measured and cut to an accurate 30 cm (12 in.) square.

STEP 5

The traced cartoon was laid on to the plasticine and transferred by drawing the tailor's wheel along the design lines.

STEP 6

The tesserae which had been selected and set out in saucers were now laid on to the plasticine along the guide lines, when necessary clipping into shape to fit into place. As each section was completed, the tesserae were pressed down, setting the thicker ones deeper than the thinner ones, but never deeper than 8 mm ($\frac{1}{3}$ in.) into the plasticine.

STEP 7

The tesserae were now all set into a satisfactory colour pattern, but several small alterations were made by shifting and replacing some with tweezers while others were straightened.

STEP 8

The entire surface was now flattened with a rolling pin or by placing a small plank of wood on top and gently hammering (62).

STEP 9

A strip of plasticine was rolled out and pressed round the whole mosaic in the form of a little wall so that the glue would be retained (63).

STEP 10

The square of sacking (previously washed and dried so that it was clean and porous) was placed over the mosaic.

STEP 11

The glue, prepared according to the recipe in chapter XI, should be of thin syrupy consistency. If it is too thin, however, it will penetrate into the cracks

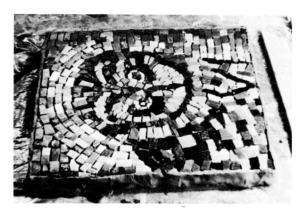

63 Retaining wall of plasticine

64 Applying the glue

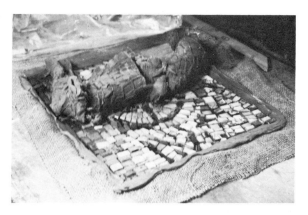

65 Plasticine being rolled off tesserae

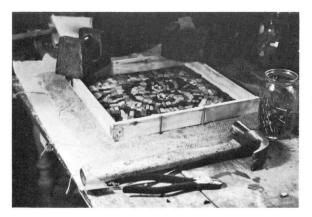

66 Framing and nailing in place

between the tesserae and prevent the grout from entering, and if it is too thick it will not penetrate through the sacking. It was brushed generously all over the sacking surface and then dabbed into the fabric with a stiff paint brush (64).

Ordinary carpenter's glue can also be used for this job but the consistency has to be carefully judged. It also is applied hot. The glue has to be left to harden for 12 hours or until set.

STEP 12

A board was placed on top of the mosaic and it was now gently reversed on to this. Working on the reverse side, the plasticine was gently peeled off and any tesserae that had failed to stick or had become misplaced were glued back again on to the sacking. The whole mosaic was now transportable and could, if necessary, be rolled up.

STEP 13

In this case it was laid on to a square of oiled paper placed over the plywood and a test was made to ensure that the sacking was still flat. If it has warped or buckled up in any way it should be wetted with a fine sprayer until it is flat and even.

STEP 14

The prepared frame (see page 109) was placed round the mosaic and nailed in place on every side (66). If the frame is to be a permanent one, eight to twelve nails can be driven through the frame into the inside at regular intervals. These will bed themselves into the cement when it is poured on to the mosaic.

STEP 15

The expanded metal was cut to the correct size, 13 mm (half an inch) smaller than the frame all round and tried for fit, making sure that it was perfectly flat (67).

STEP 16

A grout, which is a thin mortar mix used as infilling between the tesserae, was made up in the following proportions:
 1 part lime
 8 parts sand
 2 parts cement
It was mixed with water which was added gradually until it was of the consistency of thick syrup. This

mortar was poured over the mosaic to a depth of 6 mm (¼ in.) and pressed into the cracks with a stiff brush until they were completely filled with the grout mortar (68, 69 and 70). This was left to dry for an hour.

STEP 17

The expanded metal was placed on to this grout mortar (71).

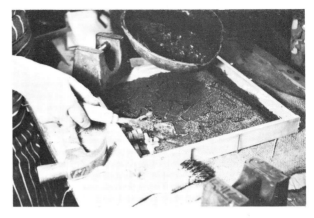

69 Stage 2

67 Cutting wire

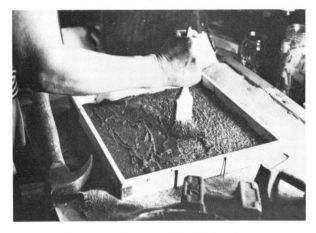

70 Grout being pressed into cracks with brush

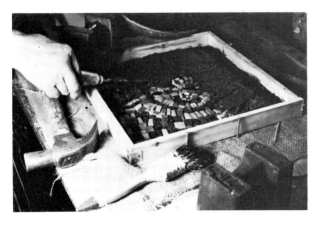

68 Grout being applied—stage 1

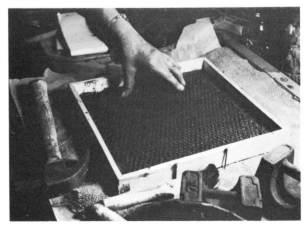

71 Fitting wire reinforcing onto mosaic

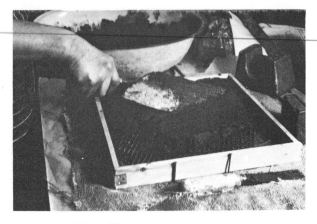

72 Trowelling on mortar

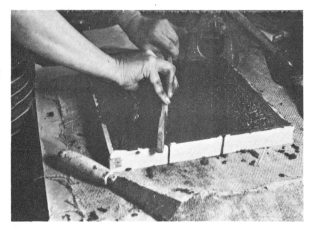

73 Passing wooden batten over to level

75 Final mosaic

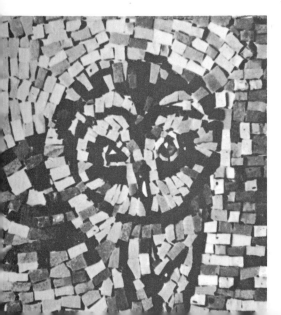

The following mortar was now mixed to fill the frame:

 1 part cement $2\frac{1}{2}$ parts sand

Sufficient water was added to mix to a stiff consistency. Too much water will weaken the setting. This mortar was trowelled on evenly and tamped down until the water began to rise, special attention being paid to the edges near the frame and corners (72). A wooden batten was passed across the surface to give a level finish (73). Had the mosaic been intended to go on to a wall it would have been left rough and uneven to key it on to the wall surface.

STEP 19

After it had dried for three to four days (it is most important to ensure that it is absolutely dry) the nails were removed and it was turned over to strip off the sacking. This was stripped off gently, being easily removable as the dampness in the cement had caused the glue to become soft and gelatinous (74). If by any chance it should stick, sponge it with a damp sponge and it will peel off at once. Odd tesserae that may have slipped out of place should now be glued back into position with any handy adhesive.

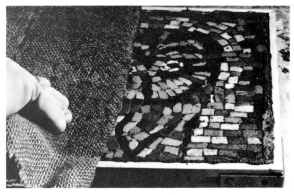

74 Peeling off sacking

STEP 20

The wooden frame was removed by unhooking the hinged corner and lifting it away from the cement sides, taking care not to damage the edge by knocking it to free it from the frame.

STEP 21

The finished mosaic was laid sideways and sponged with warm water to remove all traces of glue and sacking (75).

A final example of the Reverse method is shown (76, 77). These two panels, each being 244 cm × 61 cm (8 ft × 2 ft), were carried out in the sectional method described at the beginning of the chapter and taken to the site in Ilford where they were laid on the prepared wall in one day by three people. The tesserae used were smalti and vitreous mosaics.

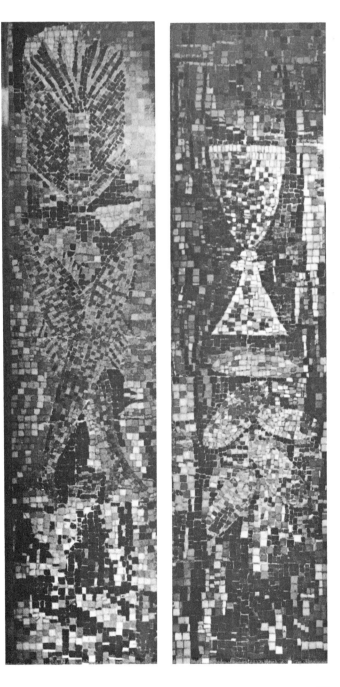

76 *Church mosaic panel 1*
 by John and Helen Hutton
77 *Church mosaic panel 2*
 by John and Helen Hutton

Ceramic Tesserae
V

78 Kiln props and cones

Mosaics that may be designed from this type of tesserae range from great murals that cover the whole side of a building, the basic units of which may be of the maximum size that a kiln can take, down to small panels composed of minute tesserae that have been fired in a small test kiln. The size, thickness and shape can be of your own choosing, the colour alone depending on your skill with glaze mixing and firing. The texture treatment of the surface is an important part of the technique when one remembers that a mosaic of this kind is a shimmering face of perpetual movement, in changing light, alive and throbbing, and even on a large wall mural this quality must still emerge within the scale of the mosaic. Some of the contemporary Mexican murals illustrated (figs 159 to 165) express the values of such textural treatment.

EQUIPMENT

A kiln—see Appendix for type and price (or the availability of a kiln)

Kiln furniture—consisting of batts to support shelves, props, shelves

A sieve—a 150 mm (6 in.) diameter 120 mesh is usually sufficient

Seger cones—for measuring kiln temperature. Numbers O2a, O1a, 1a (78)

Scales—for measuring glazes. Postage scales are adequate

A rolling pin Plastic buckets

Plastic measures Brushes

Cutting wire—for cutting clay

Palette knives, scrapers, pointed sticks

Scrim, heavy-weight plastic—on which to roll the clay

A plaster batt or concrete slab for kneading the clay. This can be bought from suppliers or made from plaster of Paris (see page 108)

A pestle and mortar—is useful but not essential (79)

A flat tray—(similar to a developing tray) for melted wax

A metal ruler

MATERIALS

Clay—with a firing range of 1050° to 1100°C

Paraffin wax—454 grm (1 lb) is sufficient (for coating the undersides of the tesserae)

Plaster of Paris—(if required)

Prepared transparent glaze—firing range 1050° to 1100°C)

Body stains—for using with slip

Glaze stains—to mix with transparent glaze to produce colour

Oxides—if you prefer to mix and blend your own colours. The following are usually required:

Iron oxide Manganese oxide Chrome oxide
Tin oxide Black cobalt oxide
Black copper oxide, Copper carbonate

Flint or kiln wash—to coat the kiln shelves to prevent the tesserae from sticking

Ball clay—for making your own glazes and slips

Lead bisilicate (*Podmore's* P 29)—for making your own glazes

Other ingredients must be purchased if the more advanced glaze recipes are used.

These are the basic requirements for making your own tesserae, although other equipment and materials may become necessary as you progress. The collection of objects for impressing textures should be part of the equipment and your eyes should always be on the alert for these.

Standard modelling clay can be obtained from any pottery supplier in terracotta, buff or grey (see page 134), but if there is any opportunity to dig and prepare the local clay, the firing range would be a matter of experimentation. How to prepare newly dug clay is described on page 109. In Cambridge, where I live, the clay from Chatteris can be bought ready prepared and is used widely by local potters.

Modelling clay from the supplier generally comes in 50 kg (hundredweight) plastic bags and can be kept in these in a cool place or transferred to a reasonably airtight container and wetted occasionally if it shows signs of drying out. Never let the clay become quite dry or it will have to be broken down and covered with sufficient water to saturate it, then slowly drained and dried out until the right consistency is reached—a process which can take a week or longer again depending on weather conditions. If you are using clay fairly regularly, keep it well wrapped in a damp cloth which should be wetted frequently. A bucket of water should be kept handy in which to throw left over bits of clay so that they may be slopped down and kept for use at a later date.

The glazes should be transferred to glass screw-topped jars where possible and legibly labelled. The measures and containers be kept very clean as a few grains of oxide left in the bottom can radically affect the next glaze that is prepared.

79 Pestle and mortar

80 *Kneading clay—stage 1*

81 *Stage 2*

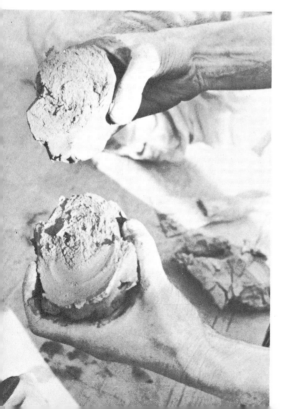

PREPARATION OF THE CLAY

This is begun by placing a good-sized ball of clay on a table or plaster batt (which may be obtained from suppliers or made from the recipe in chapter XI), and knead it as you would for pastry. If the clay is rather too damp it is essential to have a plaster batt as this will absorb some of the surplus moisture. This kneading process expels the air bubbles that may be in the clay which could cause cracking and distortion during firing. It also makes the clay more workable.

It is then placed on a square of sacking, scrim or heavy plastic, laid on a stout bench or table and rolled out with a wood roller until it reaches the required thickness; 3 mm to 6 mm ($\frac{1}{8}$ in. \times $\frac{1}{4}$ in.) is about right for tesserae. For accuracy, place a couple of wooden battens of the right thickness on each side and roll across these (83).

82 *Stage 3*

83 *Rolling out clay*

After this stage there are two methods of treating the clay to prepare it to receive the surface treatments. In the first case it is allowed to dry completely, taking about a week. It is then given a light firing (900° C), known as the biscuit firing, and a glaze is applied following this. It is then re-fired at a higher temperature (1100° C), and although this method produces more intense colour, the second method is the one usually employed for tesserae making as it involves only one firing.

In this second case the clay is dried for a few hours only until 'leather dry', the surface treatments and/or the glaze is then applied and it is fired at the higher temperatures (1050 to 1100° C).

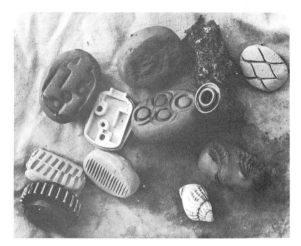

SURFACE TREATMENTS

Various forms of surface treatments are applied to the clay before glazing which enhance the reflective properties, giving greater vitality to the tesserae.

I Impressing

This is done by stamping different pattern moulds on to the clay after it has been rolled out. The clay body must be of the right consistency to take this. If it is too soft and wet a sticky mess will result, and if it is too dry it will probably crack when pressure is applied. The illustrations (84, 85) show the various objects that can be used for this impress treatment, but you can also make little moulds yourself, biscuit-firing them. They are made as follows:

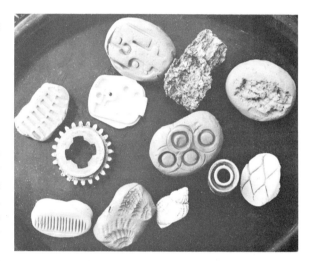

Roll up some balls of prepared clay of about the size of a small egg. Pinch together on one side to form a handle (86). Holding the mould by this handle, press it into some interesting surface (such as basket weave) to give a strong impression on the clay surface. When you have made a collection of these, put them in the kiln when a biscuit firing is being done. Many interesting impress moulds can be made in this way. Some suggestions for materials and things that you could press the clay into are: cogs and bolts, dried sticks, dried seed-pod sections, leaves, bark, the end sections of straw, cheese grater. Obviously original ideas will spring to mind (87).

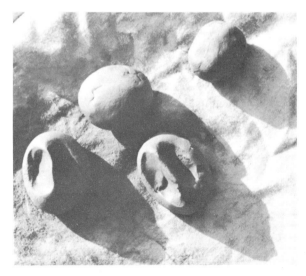

84 Impressions from pinched moulds A
85 Impressions from pinched moulds B
86 Pinched moulds

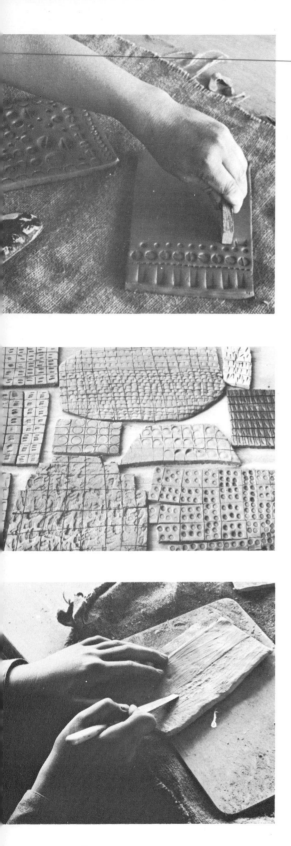

2 Sgraffito

This is a very old technique which consists of scratching or scoring lines and patterns, either direct on to the leather-dry unfired clay or through a pigment, or on to the clay *after* the glaze has been applied. By scratching through the glaze covering with a pointed instrument, the raw clay is exposed, and a line pattern is thus formed of variable thickness.

3 Wax resist

In this technique, the line pattern is drawn onto the almost dry clay with a wax pencil, or sharpened candle end, or with a brush dipped in melted wax, *before* the glaze is laid on. As the glaze cannot adhere to the wax, the areas covered by it are left clear of glaze, and thus form the pattern (90, 91).

4 Flashing

For this treatment a very dilute glaze is used and wiped on to the clay lightly with a sponge, or brushed over with a large coarse brush before firing.

5 Pattern painting

Painting patterns on to tesserae is only worth while if you are making rather large-scale ones, two inches or more in area. The pigments used for this are simply prepared by mixing a teaspoonful of transparent glaze with a tablespoon of water and adding very minute quantities of the required colour (suppliers' colours are suitable for this). This is painted over white glaze. Alternatively, underglaze colours can be painted direct on to a white slip and then glazed (92).

6 Sanded texture (raised)

For red On to the raw clay brush a mixture of diluted clay (to the consistency of thin mud) and golden sand and fire this at 1100° C.

For white The same method as above but substitute silver sand for the golden sand.

87 Impressed tiles
88 Impressed textured tesserae
89 Sgraffito

OTHER TEXTURES

On to the raw clay many interesting shapes may be
pressed by a slightly different method from Impress-
ing. This technique needs fairly large tesserae to be at
all effective, but would be very suitable for larger
murals, possibly on outdoor sites. Some of the
suggestions are: Twigs or branch forms, hay and corn
grasses, fish backbones, sunflower or other large
seeds, and, for smaller tesserae, try sawdust, wood-
wool or smaller seeds. These are rolled or pressed into
the clay and fired in the kiln in a reducing atmosphere.
Under these conditions the pressed forms will burn
away leaving only their imprinted pattern. Reducing
should only be done under the guidance of an expert
potter as it requires skill and experience.

SLIPS

A slip is a mixture of sieved clay diluted with water to
the consistency of cream. The tesserae are either
dipped into this mixture to coat their upper surface or
this mixture is painted on. In both cases it is advisable
to coat their undersides with wax before the slip is
applied. Paraffin wax melted in an ordinary baking tin
is used for this purpose.

Both slips and glazes can be coloured by the
addition of oxides. A coloured slip can be covered
with a different coloured glaze. An ordinary white slip
gives a good base for any coloured glaze and can be
used over a red or a grey clay if required.

GLAZES

A glaze is the glass-like coating that is applied to the
clay body to protect it, to make it impervious to water
and to decorate it. It can either be applied to the raw
clay or after the biscuit firing, but, as mentioned
earlier, is usually done to the raw clay in the case of
ceramic tesserae.

In the process of firing both the clay and the glazes
expand and contract, and because this expansion and
contraction should measure the same in the clay as in
the glaze, it is advisable to incorporate some of the
clay in the glaze—up to 30% may be included.

90 Wax resist—stage 1
91 Stage 2
92 Pattern painting

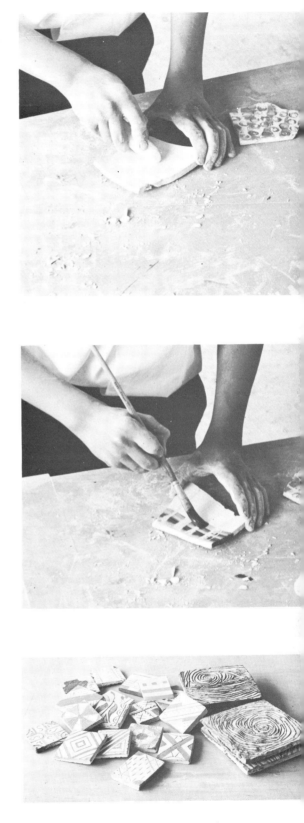

65

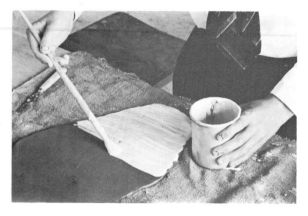

93 Brushing on glaze

94 Glaze trays

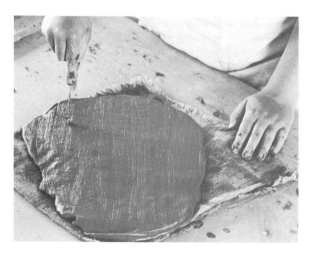

95 Cutting clay slab

Most pottery suppliers will, however, send a glaze to fit the clay they stock and it is only when a special glaze is required that the above rule of fitting the two must be observed.

The following glazes are recommended and can be obtained from Podmore and Son Ltd:
For use with:

CLAY	GLAZE
$B\frac{34}{1}$ (1100° to 1150° C) buff	– W 165 transparent leadless – A 9 opaque tin (white)
$B\frac{31}{1}$ (1100° to 1150° C) terracotta	– W 165 transparent leadless – A 9 opaque tin (white)

Of the two glazes mentioned above, No. W 165 is colourless and is added to the oxides or glaze stains in the proportion stated in the recipes. The opaque tin glaze No. A 9 has an attractive milky quality and when used in small quantities with the oxides or stains gives a semi-transparent sheen which is particularly suitable fo tesserae. It is worth experimenting with.

APPLYING SLIPS AND GLAZES

Glazes are purchased finely ground ready for mixing and the usual recommendation is that sufficient water be added to give a finished weight of 31 per half a litre (pint) for all leadless glazes. Slips are mixed by adding water to the clay and stirring thoroughly. It should be of the consistency of cream—with water poured off it too thin or added if too thick.

Both the slips and the glazes can be brushed on to the clay (93) and indeed for small quantities this is most practical, but it is always difficult to keep the buckets of solution constantly stirred, and the solid matter falls to the bottom leaving only a water mixture to be brushed on.

The following is the better method where a slab of tesserae is to be dipped: Melt paraffin wax in a large baking tin (94) (of an area to take the clay slab) and dip the underside of the clay into this, coating it completely with wax. This ensures that no glaze melts on to the kiln shelf during the firing causing the slab to stick. When the wax has hardened, in a few moments, the clay can be dipped into the prepared slip or glaze, which must be kept well agitated. Again a baking tin or a large photographic developing tray is the best receptacle to use for this operation. Before dipping, be

sure that the slab is free from dust or greasy finger marks, as this will prevent the glaze from sticking. Two coats can be applied but are seldom necessary if the right consistency is used.

Do not attempt to dip too large a section of clay slab or it will bend and become warped or misshapen and the resulting tesserae will be difficult to bed down. Allow a short time for the glaze to dry before cutting into sections (95). It may be scored or cut into the required shapes before glazing or afterwards, although it is quicker to load a kiln with several slabs than many small tesserae. Do not confine your shapes to squares and rectangles; many other shapes and varied sizes should be prepared to build up a stock that will be used for many mosaics (96).

When they have not been separated before firing, they will come out of the kiln stuck together, but can easily be separated by tapping gently with a tack hammer on the underside or equally simply by parting on the scored line with a tile nipper (97).

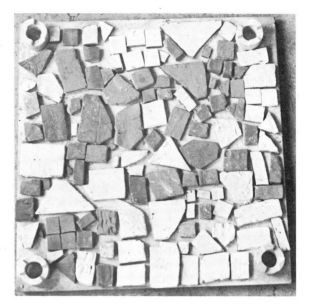

96 Tesserae laid on kiln shelf for firing

FIRING

The kiln shelves (98, 99) must be coated with flint or a kiln wash before tesserae are stacked, even though the problem of running glazes should have been dealt with by waxing. Use 38 mm (1½ in.) kiln prop to support the shelves (78) one directly above the other. For tiles or heavy-weight tesserae, three props for each shelf are used, one at each back corner and one in the middle in front; this gives better distribution of weight and a little more room on the shelves. Four props are often used for light tesserae and should be placed before the tesserae are laid in.

For firing raw glaze, as in tesserae, although cones No O2a, O1a, 1a are placed in the kiln before switching on, the temperature must first be brought slowly to 750° C (as for biscuit). The spy hole bungs are then inserted and the temperature should rise to 1100° C. When the cones have bent to the base this temperature will have been reached, the firing taking anything from 9 to 12 hours depending on the size of the kiln. It is best to prepare the kiln the night before so that all will be ready to switch on early in the morning, and as firing is expensive, be sure and have a full load.

When the correct temperature has been reached switch off the kiln and allow to cool down overnight removing nothing from the shelves until the kiln is

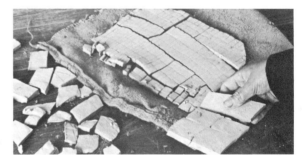

97 Separating tesserae

98 Laying tesserae on kiln shelf

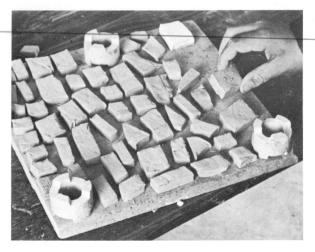

99 Stacking kiln

cold. The tesserae are then removed, separated, and stored in boxes or jars (never in tins).

It is always worth while doing several test tiles with each firing to try out different glaze experiments. Keep a notebook beside you with details as to quantities and variations in firing conditions for each group of tesserae made. If the colours are not what you expect (and they probably won't be the first time) you can vary the amounts of oxides or glaze stains very minutely, or try firing at a higher temperature. Infinitesimal quantities of oxides can give great variation in colour, and changes in firing temperatures may alter the texture, giving interesting crazed or run glazes.

Unlike pottery, where firing is nearly always fraught with anxiety, tesserae making always has a happy ending. Everything that is fired can be used for some mosaic or other—eventually!

GLAZES THAT CAN BE MIXED

The following is the basic recipe for a lead bisicilate glaze which can be used with the colours below. It is approved by the Ministry of Education (non-poisonous) and is a shiny transparent glaze that fires at $1100°$ to $1160°$ C.

25% ball clay (*Chatteris*)
75% lead bisicilate (*Podmore's* P 29)

Method of working

Weigh out the clay and the lead bisicilate according to quantities. Have ready a bucket half full of water and put in the dry materials. Sieve through a 120 sieve, stirring before and during sieving. After this is done, allow to settle and if it is too thin, pour off excess water. Cover until ready to use.

FOR A SEMI-TRANSPARENT GLAZE

Add 5% tin oxide to the glaze recipe.
(If this is used over red clay (unslipped) the resulting shade will be a pale pink, but if it is fired above $1160°$ it will be a brownish grey).

FOR AN OPAQUE GLAZE (This is white and glossy)

Add 10% tin oxide to the basic recipe.

facing page 69
Mountainous Landscape, *53 cm × 76 cm (1 ft 9 in. × 3 ft) by Jane Muir*
Detail of a high relief mosaic using Lakeland slate, glass fusions, lead came, aluminium castings and vitreous tesserae, embedded in a lightweight cement on a blockboard support through an expanded metal mesh

68

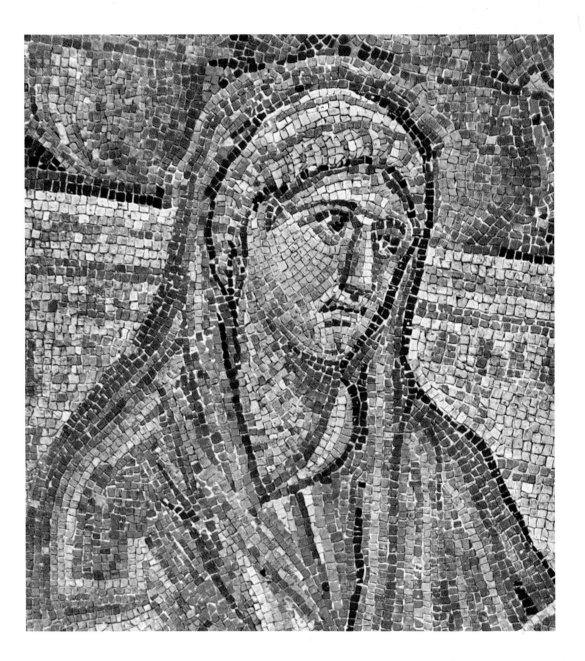

Detail from the Santa Puderziana Rome, dating from the end of the fourth century

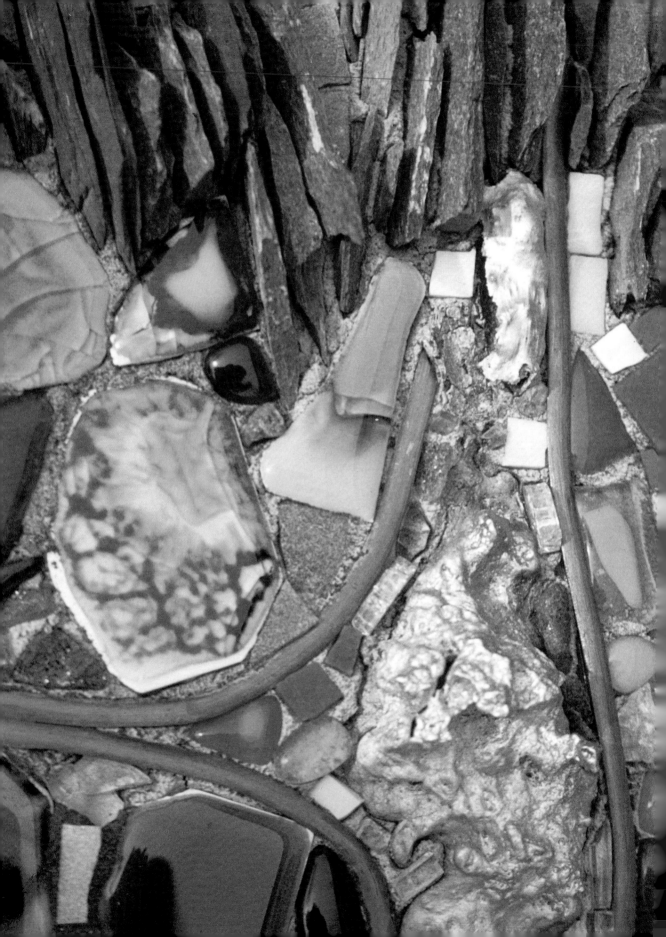

Glaze colourings

The following are some of the approximate shades obtainable.

To 100% of transparent glaze (*Podmore's W 165*) add the following:

Blue
½% cobalt 1% copper carbonate
1% red iron oxide 2% zinc
As a base for the above recipe a white slip should be used.

Green
To 100% transparent glaze add:
1–5% copper carbonate (or a bought glaze stain)

Red brown
To 100% transparent glaze add:
5–9% red iron oxide or try to dig local red clay. Slop this down with plenty of water and sieve through an 80 sieve. Or buy red clay from suppliers.

Yellow
First make a slip of 100% white ball clay and 5% red clay.
Cover this with a 100% transparent glaze to which has been added:
5% iron oxide (for rich amber) or
2% iron oxide
1% manganese (for a honey glaze)

Black
To 100% transparent glaze add:
1% cobalt 8% iron oxide
2½% manganese

Silver
Paint black copper oxide on rather thickly to give silver tone.

Brown
To 100% transparent glaze add:
7% iron oxide 1% manganese oxide

Purple
To 100% transparent glaze add:
Manganese carbonate

The following is a section of rather more complicated glazes for those who have time and inclination for further experimenting. They fire at 1050° to 1080° C.

Glaze A (transparent)
 20 grammes lead bisilicate
 70 grammes borax frit 10 grammes china clay

Glaze B (transparent)
 91 grammes lead bisilicate
 4 grammes zinc oxide 5 grammes china clay

Glaze C (semi-opaque)
 80 grammes borax frit
 2.5 grammes zinc oxide
 12.5 grammes micronized sircon, grade 1
 5 grammes china clay

Glaze D (matt)
 36 grammes lead bisilicate
 17 grammes borax frit
 4 grammes zinc oxide
 2 grammes tin oxide
 35 grammes waterground zircon
 4 grammes china clay
 2 grammes titanium dioxide

For each 100 grammes of these glazes, add the following oxides to obtain the approximate colours shown below:

Oxides	Glaze A	Glaze B	Glaze C	Glaze D
2 grms copper oxide	mazarin blue	medium blue	azure blue	sky blue
3 grms copper oxide	sea green	sea green	turquoise blue	turquoise blue

Oxides	Glaze A	Glaze B	Glaze C	Glaze D
10 grms iron oxide	treacle brown	treacle brown	chestnut brown	indian red
5 grms manganese oxide	mid brown	mid brown	purple brown	purple brown

Examples of ceramic mosaics are illustrated (100, 101).

CERAMIC (set with a direct adhesive)

This was another example of the random type of designing, using ceramic tiles and pottery tesserae. It was designed and set on the board in one and a half hours to show in an art school exhibition, the object being to display ceramics as a mosaic material.

Materials

Home-made ceramic tiles in varying sizes—75 × 75 mm (3 in. × 3 in.), 50 × 50 mm (2 in. × 2 in.), 50 × 25 mm (2 in. × 1 in.), 125 × 75 mm (5 in. × 3 in.) etc. Many surface patterns were stamped on them and while some had a high glaze, others were matt. Many muted tones were used.

Mortar
$\frac{1}{4}$ litre ($\frac{1}{2}$ pint) tin *Unibond* adhesive

Wood
1.98 m × 50 mm × 13 mm ($6\frac{1}{2}$ ft × 2 in. × $\frac{1}{2}$ in.) softwood framing
Chipboard baseboard cut to 350 mm × 560 mm (14 in. × 22 in.).

100 Ceramic mosaic

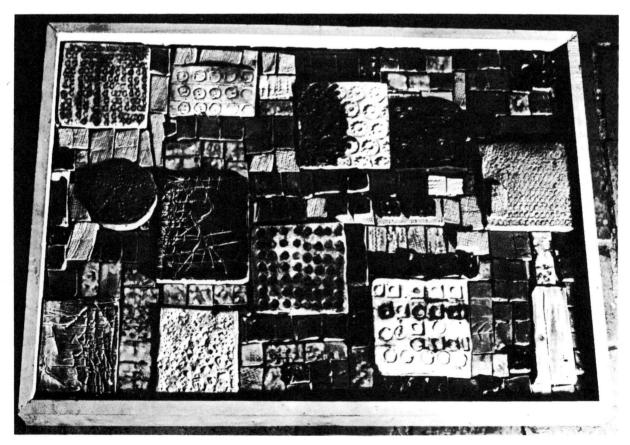

Tools

Spatula for applying adhesive
Tile cutter Carpentry tools

Method of working

The ceramic tiles, which were the result of various glaze tests over a period of several weeks, were all set within the frame and moved about until they formed a pleasing pattern of shape and colour. They were then lifted, one by one, and the adhesive brushed on the underside with the spatula.

The setting time was very rapid—a matter of ten minutes or so—and it was not possible to have second thoughts about the design.

No grouting was done to this or either of the two preceding examples as in all cases the spaces formed a part of the design. Fig. 101 shows an assemblage of ceramic materials combined with stones and mosaics.

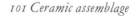
101 Ceramic assemblage

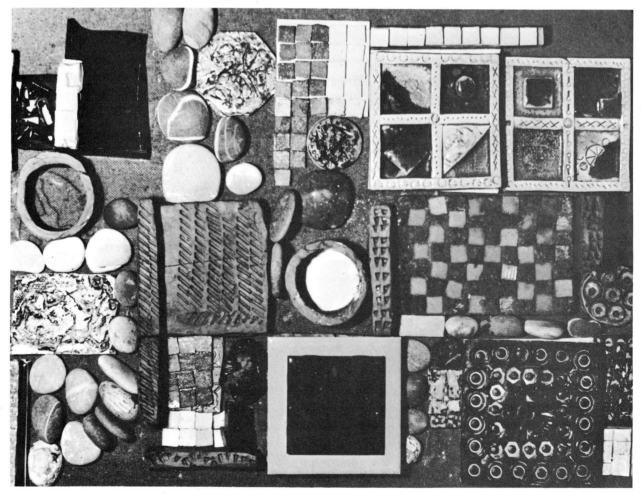

Stained Glass Mosaics VI

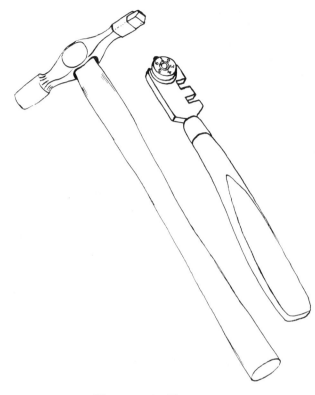

102 Glass cutter and hammer

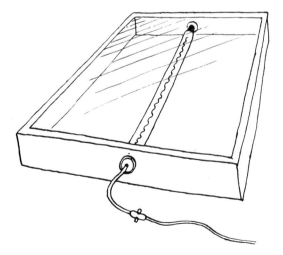

103 Diagram of light box

By the use of stained glass as a mosaic medium some startlingly beautiful results are achieved. Several different technical methods are in use and it is very probable that others will be evolved by the creative and imaginative designer. Perspex also can be used in much the same way as glass, but with rather less interesting results as the colours are cruder and the material itself can never rival the glow and glitter of glass.

Several different kinds of glass are used for mosaics, depending on what you want to produce with it and the technique you employ. Cut stained glass tesserae are excellent for the conventional mosaic together with smalti and vitreous tesserae, provided they are used on a white plaster background or have been backed by gold or silver paint. If this is not done they will reveal little of their colour.

EQUIPMENT

Glass cutters (102) (single or multiple wheel)
Steel rule Pliers
Cutter lubricant ($\frac{1}{2}$ paraffin to $\frac{1}{2}$ lubricating oil)
Palette knife (for puttying glass mosaic)
Graphite glass pencil Glass cleaner
Polishing cloths
Felt pad or cloth (for cutting on)
Mortaring tools (see chapter II) Hammer
Paint brush (for applying gold or silver backing)
Light box (103)

MATERIALS

Stained glass (various types)
Plate glass Adhesives
Slab glass Putty mix (see chapter X)
Bottle glass Backing boards
Mortars Reinforcing wire

SLAB GLASS

As described under *Workplace, Equipment and Materials*, chapter II. The price varies considerably according to the tint of the glass and on the whole is very expensive owing to its thickness. The most costly are usually the selunium shades of red, orange and yellow.

The technique of cutting this glass (105) is by no means easy in view of its thickness. It should be scored with a glass cutter in the usual way, dipping the cutter in lubricating oil first, and then tapped on the opposite

side with a hammer (tungsten carbide tipped) until it breaks cleanly along the scored line. Some glass firms will cut cubes or rectangles of this glass if requested, but it is obviously worth mastering the cutting technique yourself. An alternative to cutting is 'shelling' and using the haphazard shapes with their facetted surfaces in a random design. Glass is shelled by tapping sharply up against the edges with the type of hammer illustrated in fig. 102.

STAINED GLASS (traditional)

Several varieties of this are obtainable. It can be bought by the sheet, giving you the opportunity to choose the colour range you prefer and must be cut into the rectangular shapes required. The cost of it will vary considerably according to both the type of glass chosen and the colour. Ask to see the cheapest glass first as this is quite satisfactory for glass mosaics, always providing you can get the colours you want, but if more subtle shades are preferred, then you may have to buy better quality for a few of these colours.

Stained glass offcuts can often be bought and then you will not need to do any cutting. They should merely be sorted into colour groups and stored in boxes or similar flat containers.

Flashed glass should be mentioned as it has the colour fused on to one side only and as this side is much harder than the unfused side, cutting should never be attempted on the colour side. A brief cut will show you which side is which and this can also be seen when held sideways against the light.

BOTTLE GLASS

This can be collected both on beaches and at home. The glass from the beach is generally worn and sanded down by the action of the sea and can be used as it comes.

Ordinary bottles that have been found or unearthed in rubbish tips often have superb shades of deep green, ice blue or amber brown. To break them into manageable sized fragments they must be covered with cloth or sacking or placed in heavy paper bags before being gently hammered. Do not pulverize them, and wear gloves and an eye shield as a precautionary measure. The circular bases of wine bottles make an effective mosaic embedded in plaster. The base usually falls free when the bottle is broken, or you can pour boiling water into it.

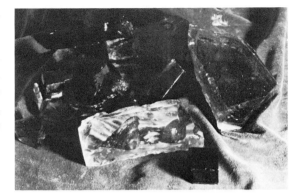
104 Slab glass cut and shelled

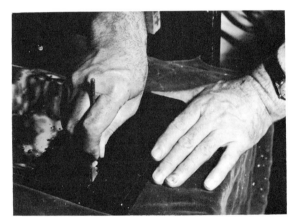
105 Cutting slabs

106 Cutting stained glass—method 1

107 Cutting stained glass—method 2

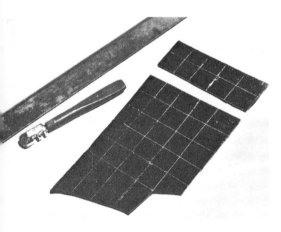

108 Glass scored for tesserae cutting

GLASS CUTTING

Clean the glass with liquid detergent to remove any grease or grit and lay the sheet of glass on a thick cloth or felt spread on a level surface. It is essential that this is absolutely flat or the glass will crack under the pressure of the cutter. Hold this in either of the two ways shown in the illustrations (figs. 106, 107). There is no right way to hold this tool provided it is held and maintained at right angles to the glass and it is better to experiment a little and find a grip that suits you best and seems natural. Find some odd bits of glass and practise the following method: lay a steel rule or metal straight-edge across the glass and draw the cutter sharply and firmly along it, applying slight but even pressure all the way along.

You can either draw the cutter downwards or upwards on the sheet of glass. From whatever direction you prefer, make a clean steady sweep of the cut, since each time you hesitate in the stroke the rotary wheel of the cutter is re-aligned, resulting in an irregular cut which will cause the glass to fracture instead of splitting cleanly. When cutting flashed glass, remember to cut it on the underside of the colour face. Test by making a small scrape on each side; the coloured (flashed) side will reveal a line of clear glass underneath.

For cutting practice for tesserae, score a sheet of glass in a series of parallel lines 19 mm ($\frac{3}{4}$ in.) apart, always cutting away or towards you, never across in front of you. Now turn the sheet round and score the other way to make 19 mm ($\frac{3}{4}$ in.) squares. You can, if you like, make rectangles or squares of other proportions. When you have scored the sheet (108) turn it over and gently tap across the lines with the ball end of the cutter. It will break easily into squares across the cuts. Remember that the glass is always tapped on the reverse side from the cuts.

Glass varies a great deal in toughness and one piece may be more difficult to cut than another. Hard glass can be laid along the line of the steel rule pressing the scored line against this edge or tapping with the cutter. Smaller sections which prove stubborn can usually be prised off with pliers.

Generally speaking, the more difficult shapes, such as circles, other curves and triangles, are not required for glass tesserae as these shapes can be built up from several small pieces, and the technique of cutting complicated forms comes within the province of the stained glass artist and is not for this book.

PREPARING GLASS TESSERAE

As previously stated, where stained glass is to be used in an ordinary mosaic (not as a translucent medium) it is necessary either to back it with some reflective material or to lay it on a background of white so that the colour will retain its brilliance. The only exception to this is when a black shiny tessera is required, as on an ordinary cement mortar almost any dark stained glass will read as black.

A light background can be created in several ways. Firstly, by any white adhesive used, although a plywood or hardboard ground will allow the colour to glow through. Secondly, a white setting ground such as plaster of Paris is equally effective, bearing in mind that this ground sets almost instantly and the Reverse method must be used.

Finally the tesserae can be used on a dark ground if they are backed by gold or silver leaf, copper or aluminium leaf which can generally be bought in booklets. It is not advisable to use ordinary gold or silver paint as the action of the cement may dissolve it, leaving the blank unreflective glass surface. Opinions vary about this however, and some artists say that the dissolving of the gold and silver paint can give a broken shimmering sheen which is unusual and interesting.

Metallic leaf which may be used for backing individual tessera is costly and rather difficult to apply and must be glued on with some type of PVC waterproof adhesive. These metallic foils are supplied in paper books, each leaf being protected by tissue paper. When applying the leaf avoid air currents as the delicate, fragile nature of it can be destroyed by a slight draught causing it to crumple and disintegrate. Working with the hands inside a box should eliminate such disasters. Silver foil makes an effective and cheap backing. The foil sheet should be laid flat on the firing tray and the glass fragments arranged upon it. The temperature is then raised until the glass begins to melt and oxidize. The metallic leaf backings are fired the same way.

FUSING GLASS IN THE KILN

Both stained and bottle glass may be melted down in a kiln. Regulation sized tesserae can be made by cutting a supply of rectangular shapes and firing until they melt into toffee-like segments. Larger discs may be

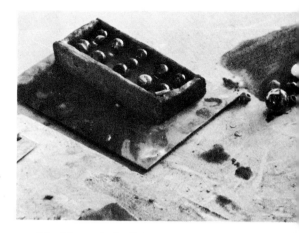

109 Marbles ready for firing

110 Tracing paper over light box

made in a similar manner. Glass in this state is the ideal form for children to handle as the sharp edges of cut glass tesserae are too dangerous.

Absorbing experiments in relationships of colour can be made by placing small fragments of coloured glass on larger ones of a different colour and firing to a molten state. Both pieces must be of a compatible type or they may break or fracture on cooling, although the latter condition can produce original, useable material. Further experiments can be carried out using marbles, glass beads or buttons. Laying fragments of bottle glass is often effective but can give disappointing results since it is difficult to know beforehand whether they are compatible. But if you have a small space left in the kiln, it is always worth trying.

The procedure for firing ordinary glass tesserae is as follows: cut the glass into rectangles or break the sheet glass into the approximate sizes you want. If larger pieces are required, place the fragments into an earthenware flowerpot container where it will melt into a multi-coloured disc when molten. In either case, the base of the kiln shelf or earthenware container must be well coated with a thick layer of kiln wash so that the melting glass will not stick to the shelf and, by becoming permanently attached, ruin the kiln. This wash may be made up of four to five parts of powdered flint to one part of liquid china clay, or ceramic grade whiting mixed to a paste with water. The kiln floor should first be damped, and after a thick layer of kiln wash is applied it must be allowed to dry completely before the glass is placed onto it. Some of the wash will stick to the base of the tesserae enhancing its reflective properties if they are not already metallically backed. Unless you particularly want the glass to emerge as large molten segments, arrange the fragments on the shelf so that they do not touch at any point and are at least 25 mm (1 in.) from the edge.

Melting points

The following are the approximate temperatures for firing glass of average hardness. These figures will vary considerably according to the type, so this is only a rough guide and you must experiment with the glass available. 600° C to 700° C Thin glass begins to bend at the edges. 730° C to 750° C. Edges of stained glass become completely rounded. 860° C and beyond further distortion takes place, glass begins to bubble and needle-point. Heating beyond this point results in

a highly molten state which may crack when cool. The cooling must be carried out in gradual stages (with no sudden changes of temperature) unless you want a cracked and fractured texture to be a feature of the tesserae.

As has been seen, there are several ways of treating and preparing glass for use in mosaics and though the following examples show some different techniques for the use of glass, it must be remembered that it is a very effective medium mixed with other kindred tesserae such as smalti and ceramics.

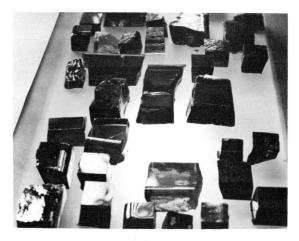

111 Glass cubes laid on light box

EXAMPLE

Setting slab glass in concrete. It is a decorative method widely in use on the continent of Europe and in the United States of America for both large and small-scale projects in domestic, industrial and church architecture. The example described is simply a small unit sample done to exemplify the technique.

Materials

The materials and their properties required for this work have already been described earlier in this chapter, but the approximate amounts used in this case are as follows:
2 half slabs, pre-cut into 13 mm ($\frac{1}{2}$ in.) cubes (mixed blues and ambers)
 About half a slab of various sized chunks, cut as required or used from stock
 Reinforcing wire (length 1.7 m or $5\frac{1}{2}$ ft fencing wire)

Mortar
 1 part Portland Cement
 $2\frac{1}{2}$ parts sharp sand
 Black *Cementone*, about 1 tablespoonful (for darkening mortar)
 Water to mix (to which 2 tablespoonfuls of *Unibond* per half litre or pint was added)

Frame
 This is made of 50 mm × 25 mm (2 in. × 1 in.) undressed softwood, and if it is to be removable, one corner should be hinged as described on page 109.

Method of working

STEP 1

A light box was used when designing this mosaic (110). To make a simple type, obtain timber of approximately 75 mm × 19 mm (3 in. × $\frac{3}{4}$ in.) to form the sides (see diagram 103). A fitting for a strip light is attached at each end of the frame. Check on the available lengths of strip light before you make your frame. Use 4 mm ($\frac{3}{16}$ in.) frosted glass for the cover—a thick glass is especially important for strength when you need to cover a large surface area. Tack a small fillet of wood around the top edges to hold the glass in place.

A sheet of heavy quality tracing paper was then placed over this light box, and the prepared frame was laid on top of this. The planning of the design which was carried out within this frame was done by placing the glass cubes experimentally in different formations, noting the fact that the spaces left inbetween would form the black part of the design. A few larger sections of glass were split, and colours rejected and replaced, until an effective pattern of colour forms emerged.

STEP 2

The glass was now outlined with charcoal on to the tracing paper.

STEP 3

A second tracing paper which had been previously oiled on the back was placed on top of the glass and another tracing made. This was to serve as a key when the glass was surrounded and sometimes covered with cement.

STEP 4

The baseboard for the mortar was laid alongside the light box, the glass then transferred to it by the shapes being fitted back into their traced forms, one by one. At this stage it is still possible to make any small alterations that seem necessary. The first tracing was left on the light box for use later.

STEP 5

The wooden frame was fitted into place and clamped down at each corner. Weights can be used if the surface is a table top.

STEP 6

The mortar was mixed as described and of a rather stiff consistency.

STEP 7

The mortar was carefully trowelled in between the glass cubes, taking great care not to move any and continually tamping down and wedging the cement between each piece while holding it in position with a finger. Two people can do this job better than one. The whole area was covered to a depth of about half an inch to fix all the glass in position.

112 Wire reinforcing laid in frame

STEP 8

At this stage the reinforcing wire, which has been previously shaped to fit within the frame, was laid in position. It should fit half an inch in from the outside edge and be pushed down to bed into the first layer of mortar. It is shown in fig. 112 being measured for fit.

STEP 9

The second layer of mortar was applied, again wedging down around the glass and edges of the frame, especially at the corners. A flat-ended wooden stick is best for this job. Great care must be taken here to prevent the cement covering the edges of the glass from flowing over the top of it. If this happens it means the mix is too liquid. After this final application a check was taken by placing the second tracing over the whole frame and tapping through each traced outline to make sure that no glass cube was covered. In trying to get this layer level it is quite possible to cover a low-lying island of glass.

STEP 10

It was now cleaned carefully and a cloth was laid over the whole mosaic and it was left to dry. The cloth should not be damped as this is liable to draw salts out of the cement and cause blooming. After four days the cement should be set and the mosaic removed from the frame by unhingeing the sides if no framing is needed.

This type of mosaic can be suitably framed and set on a stand, and placed against a window to show the full richness of its colour. Or it may be set on a table or shelf against a dark background and artificially lit from behind, where it will glow and scintillate brilliantly.

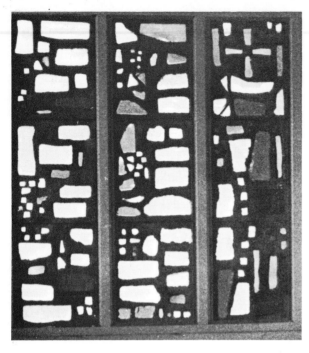

113 St Mary Cray glass mosaic by Helen Hutton

114 Example of shelled glass panel

Large-scale mosaic murals can be used as room dividers or as screens. These should be constructed by planning in manageable units that will later be fitted together in a suitable framework, and for most purposes these units should not exceed 610 mm × 610 mm (2 ft × 2 ft) square. Beyond this size they are impractical to work on and are difficult to move. It is essential that they have wire reinforcing around the edges set into the mortar to help contain the weight of cement and glass.

An example of this type of sectional mosaic is illustrated (113). The basic units were 610 mm × 508 mm (24 in. × 20 in.). Three of these were slotted on top of each other within a framework giving an overall mural of eight windows 1.8 m (6 ft) high. These were done for a small modern church in Kent. A further example in slab glass which has been shelled is shown (114).

GLASS ON GLASS TRANSLUCENT MOSAIC

The materials and equipment needed for this type of work have already been mentioned earlier in the chapter, but the special requirements for this were:

A selection of cut glass tesserae approximately 11 mm (¾ in.) square. Colours: bottle green, golden brown, lime yellow, deeper yellow, pale lilac, deep purple, prussian blue and a pale aquamarine

Backing glass A sheet of 910 gm (32 oz) (glass size)

Clear *Bostik* adhesive

Method of working

STEP 1

The design idea came from the cut section of an agate, much enlarged. It was first drawn out on a sketching pad into a satisfactory form and then translated on to heavy tracing paper with a felt marking pen to give a strong legible line contour. This was done free-hand, but the enlargement could be done by the squaring method as described in chapter I.

STEP 2

The sheet of glass was now cleaned and polished with a soft cloth. The cartoon was laid over the frosted glass light box and the sheet of glass on top of it (115).

STEP 3

The light box was illuminated and the colour selection made by viewing over the light. Have the light box placed in the darkest part and not before a window if you wish to gain fullest advantage of it. Various sheets of different coloured glass were held above until a good colour combination was selected.

STEP 4

Quantities of the tesserae were now cut and heaps of the various colours were laid in groups near the design on the light box.

STEP 5

The cut tesserae were laid along the contour lines of the design. As a general rule the lighter shades were placed against the darkest ones and the intermediate ones fitted in between to emphasize the contrasting lines of the agate form. They were laid on the glass in sections and as each section was completed, the glass was glued down with *Bostik*. An alternative to this method is to lay down all the tesserae, completing the whole design before gluing any down. In certain places the tesserae were laid one on top of another and glued two or three deep to enhance the depth of colour (116).

STEP 6

The whole design being completed, it was left to dry for 24 hours and then the glass was cleaned with a soft rag dipped in turpentine. It was now suitably framed or put *in situ* as required.

A variation on this technique is to place putty between the tesserae using the recipe in chapter XI. This putty is worked into every crack and join between the tesserae. It can be pressed in with the fingers, which is still the best method although the most hazardous, as it is almost impossible to avoid cuts. Alternatively it can be forced in with a rubber squeegee, which takes longer but is generally less painful. When all the cracks have been filled in with the putty, the glass is cleaned with crumpled balls of newspaper, worked well across all the surfaces until the glass is clear of any black putty. It must be cleaned again the following day. This dark putty gives a very beautiful stained glass quality to the mosaic and is well worth the extra trouble.

115 Traced design over light box

116 Translucent glass mosaic

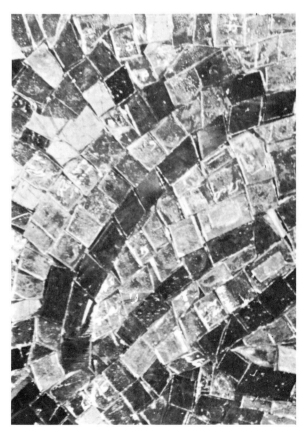

117 Glass filament mosaic 1 by Tom Fairs ARCA

GLASS FILAMENT MOSAIC BY

TOM FAIRS ARCA

This is a most interesting mosaic using off-cuts of glass in the form of thin filaments which may not be readily obtainable but can sometimes be picked up from the larger glass suppliers or cut by yourself.

The design was limited to the end result, a fine linear texture, and the effect aimed at was a richly coloured, closely textured area.

Materials

Stained glass filaments—usually pale tint colours because using them on edge tended to strengthen their colour. Ordinary pot metal colours would read as black.

A sheet of plate glass for the background

Cement—*Araldite*

Grouting cement—(Casting resin can be used if a transparent background is required)

Method of working

The stained glass is prepared, if necessary by cutting into filaments about 19 mm ($\frac{3}{4}$ in.) wide by various lengths.

STEP 1

The cut filaments were placed in bundles packed together like playing cards and cemented together with *Araldite*, having previously been arranged on the background sheet of glass according to the design.

STEP 2

When the bundles had been disposed satisfactorily they were cemented on to the background sheet, again using *Araldite*.

STEP 3

Grouting was now carried out with a fairly thin cement. In the final result the light is transmitted through the glass seen edge on. The depth of colour can be influenced to a certain extent by varying the thickness of the individual filaments. If the light falls on the surface of the glass (i.e. no light transmitted through it) the effect is a sculptural one. In this case the glass mosaic was to be used as a decorative panel, but

118 Glass mosaic by Anne Hodson

where a mosaic of this type is to be used as a room divider the design must be made on two separate sheets of lighter weight glass and then cemented back to back so that the design articulates (117).

This would be a most suitable type of glass mosaic to use as a room divider, a shower screen or simply as a decorative panel against a window or in place of a window.

Figures 118, 119 show examples by Anne Hodson.

119 Glass mosaic by Anne Hodson

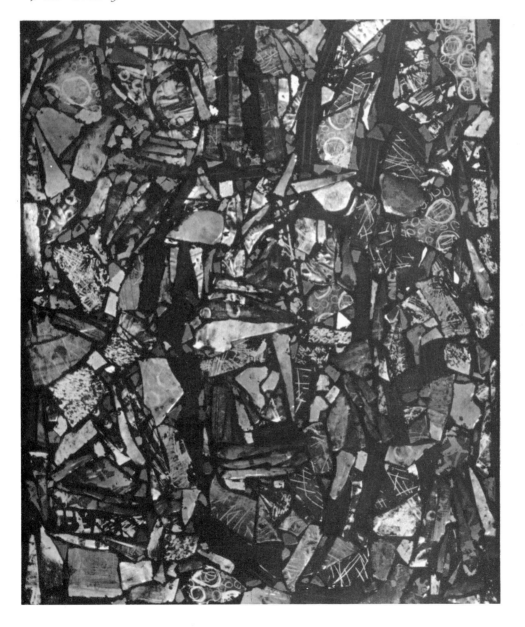

Pebbles, Stones, Flints and Fossils VII

Several examples of pavements and wall treatments using a variety of stones and pebbles are given in this chapter, and it is hoped that they may serve to stimulate ideas for arrangements and uses of these fascinating materials.

While it has been possible only to give a general picture of the specimens obtainable around the coast-line of England and in a few of the quarries, a far richer field exists in America and in some of the mountainous regions of Europe and the U.S.S.R. Idar Oberstein in Germany is a source of wonderful quartzes and agates, and pebbles polished by glacial streams can be found by rivers in Switzerland. The searching out and collecting of interesting minerals such as these can turn an interesting holiday into an exciting quest.

Flint is one of the commonest and most decorative stones found in England, but unfortunately the pattern and colour is only revealed by splitting and this is a job for an expert. It is an ancient craft that is fast dying out, but the practice of flint-knapping is still carried out in some rural areas such as Grimes Graves, at Brandon in Norfolk, where it is sometimes possible to buy off-cuts for pavements and walls. The photographs (120, 121) show a pavement made from a wide variety of flints found at Grimes Graves.

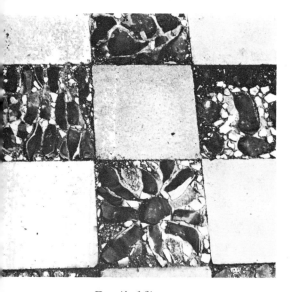

121 Detail of flint pavement

120 View of flint pavement

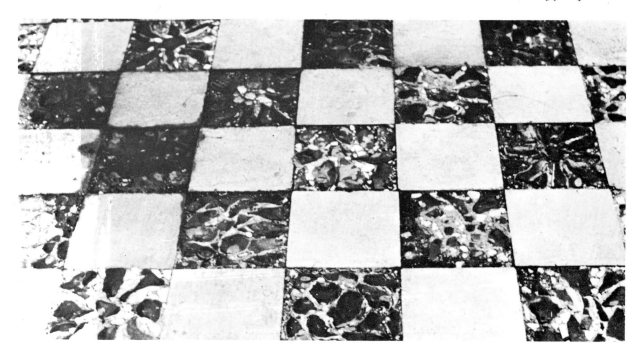

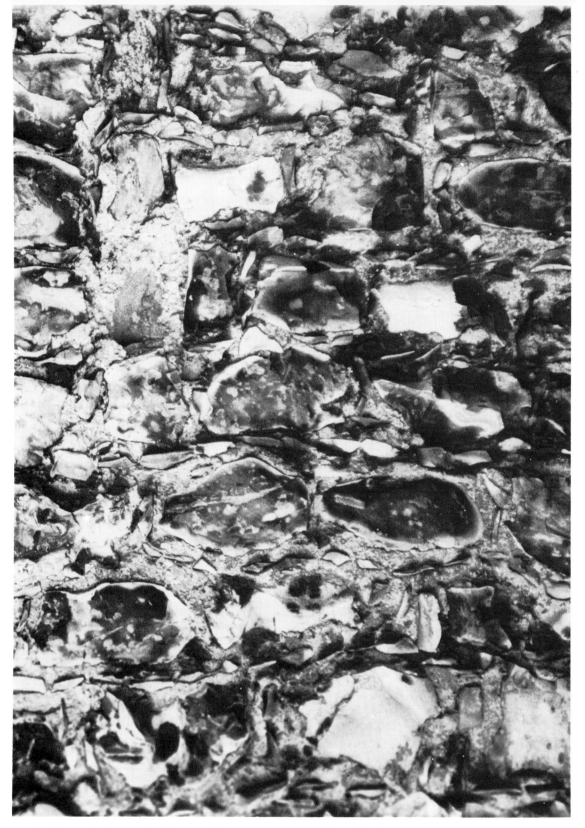

122 Section of knapped flint wall from a Norfolk church showing textural and design potentials of this medium

123 *Homage to Ise 1 approx 74 cm × 56 cm (2 ft 5 in, × 1 ft 10 in.)*
Mosaic relief in local knapped flint, riven slate *and Venetian smalti in ochres, Indian reds, ice blue, black and white on grey. Designed and made by Jane Muir*

Some striking examples showing the use of stone as a tessera medium are those illustrated (123 and 124) by Jane Muir, who has combined knapped flint, riven slate and Venetian smalti. Hans Unger's arresting mural for Brasenose College, Oxford, using rough cut marble to interpret his theme, integrates sensitively with the architecture (125). Pebbles may be used in their natural state as they were by the Greeks as long ago as 3000 BC and in this form are one of the most successful mosaic media, or they may be polished mechanically in a tumbler or laboriously polished by hand. For hand polishing you will need several grades of the type of emery paper known as 'wet-dry' in three grades, a medium to coarse, a medium and a fine grade. The pebble is dipped in water every few minutes and never allowed to dry out. Start with the coarsest grade paper and work through to the finest for the final polishing. Remember, it is only necessary

125 Mosaic by Hans Unger in rough cut marble situated in Brasenose College, Oxford

124 Ise Garden approx 71 cm × 53 cm (2 ft 4 in. × 1 ft 9 in.)
 Mosaic relief in knapped flint, riven slate and Venetian smalti in greys, olive greens, black and white. Designed and made by Jane Muir

126 *The author's rotary tumbler showing heavy duty plastic drum*

to polish one side of the stone for mosaics. Although this occupation can be amusing for children, it is often too time-consuming for adults.

Tumblers are now readily available in all sizes and are not too expensive. Little skill is required to operate them and a minimum of equipment is needed. It must be accepted, however, that polished pebbles used as a mosaic medium are only suitable for decorative vertical surfaces which will inevitably be rough and uneven. Two types of tumblers are available; the more common rotating kind (126) or the vibratory ones which are still very expensive and require fairly constant attention. Both are powered by electricity.

The tumbling procedure for the rotary type is briefly as follows: the pebbles are roughly sorted for size and loaded into the tumbler, then an abrasive in the form of a coarse type of grit and water is added. The pebbles should fill the tumbler container to two thirds capacity and then sufficient water to cover is added together with 25 g (1 oz) of coarse grade silicon carbide grit. The motor is switched on and when the belt is set in motion the drum is rotated. This is continued for a week or more, then the contents are tipped out into a sieve and washed thoroughly under running water to complete the job. This process is repeated twice more using finer grit. A fuller description is given in the manufacturer's leaflet which should be included when you buy your tumbler.

Vibratory tumblers work on the principle of very high speed vibrations, averaging 3000 per minute, thus grinding much faster and with a minimum of noise (which is sometimes an importation consideration). These are used mainly by lapidarists and jewellers as the rotary tumblers are quite adequate for mosaicists. It is useful to know the relative hardness of the different stones you are tumbling as the softer ones are liable to be ground away by the harder ones if you put a mixed load into the tumbler. You can buy a Mohs scale of hardness from a lapidary supplier but the following simple test is sufficient for mosaic tumbling. A soft stone such as calcite can be scratched by the finger nail, a harder one by a copper coin; the next on the hardness scale requires a penknife, and probably the hardest pebble that you will find, a quartz type, can be scratched only by a steel file. Mixed loads of rough tumbling material can be bought from the lapidary shop.

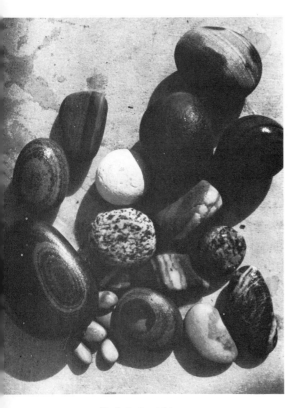

127 *Polished pebbles*

OUTDOOR USE OF PEBBLES

Since the earliest of times, in every corner of the globe where stones and pebbles have been plentiful they have been used to make patterns on streets, floors, courtyards and walls. Different peoples in such widely differing places as China, Spain, Mexico, Rome and Ancient Greece have used this enduring and beautiful medium to cover the ground and the sides of their buildings. It seems strange that they are not more widely used today, until one considers the amount of labour in man-hours.

To lay your own pavement, working slowly over a period of time, is still a possibility however, and several examples of this work are shown in this chapter.

There are two basic methods of working. The first one is to make a series of pebble inlaid concrete blocks. They can be round, square or indeed any shape you wish.

The second method is to lay the pebbles direct into the wet mortar bed *in situ*, separating the areas by paving stones, tiles, prefabricated concrete blocks or bricks.

Method I

STEP I

The shape is decided upon and a framework made, in wood if it is to be removable or in strip metal if it is to remain as a retaining wall.

STEP 2

The frame is placed on a plywood board and held in place with nails around the outside.

STEP 3

An area of reinforcing wire mesh is cut to fit within 13 mm ($\frac{1}{2}$ in.) of the edge of the frame.

STEP 4

Make a mortar of 1 part cement to 3 parts sand, adding to each 500 ml (1 pint) of water used 2 tablespoonsful of *Unibond* to ensure that the pebbles stick.

STEP 5

Level this with a flat stick and mark out design decided upon with a sharp stick or a tailor's wheel. The mortar must be firm and fairly stiff.

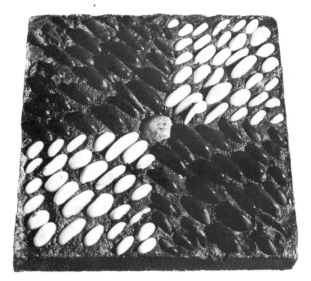

128 Pebble pavement unit

The pebbles should now be laid in, keeping to the design marked out and working from the centre outwards. Leave for several days to set properly. (See 128).

Small pebble inlaid tiles or plaques may be made in this way by using cake tins or small baking tins which have been well greased to prevent the mortar from sticking. It is possible to build up a supply of pebble plaques over the winter months, working indoors, and lay them in their patterned form into the wet mortar bed in the summer months to make a pavement. Several points must be observed when laying in the pebbles in a design. The areas should be grouped with pebbles which have a unified shape, size and colour to give contrast and form to the pattern. They can be angled, laid flat, or laid on edge, provided they are well bedded down into the mortar by hammering them two-thirds into the mortar. They should always be grouped fairly close together; if you do not have enough to do this, it is better to leave areas of mortar than to have areas of sparsely patterned stones.

Method 2

STEP 1

The side should be measured and pegged out with a line of string to surround.

STEP 2

When the site has been levelled, a layer of aggregate is laid ($\frac{1}{2}$ gravel) and spread with a mortar of 4 parts gravel (13 mm or $\frac{1}{2}$ in.), 4 parts sand and 1 part cement.

STEP 3

The paving slabs, bricks, or whatever you intend to use, should now be laid, working on a small area at a time.

STEP 4

A mortar mix of 3 parts sand to 1 part of cement is now prepared and trowelled into the spaces between the other units.

STEP 5

The selected pebbles are set in whatever formation has been decided upon into this mortar and bedded down by pressing a board over the top and hammering down.

This completes a section of the pavement, and further areas may be laid by the same method when the first part has set. On commencing each new section, remember to wet the hardened mortar thoroughly before trowelling in the new lot.

Many variations are possible within these methods, and the same treatment can be applied to any surfaces—walls, the base of pools, or interior situations.

TYPES OF PEBBLES

The following list gives the types of pebbles, rocks and stones, classified into locality, colour, etc., that may be found around the coast of England. It is possible in a book such as this to give only a very general idea of what can be found and all the interesting minerals from quarries have had to be omitted. If, however, you become interested in pebble mosaics to any extent, there are geological publications specializing in minerals, pebbles and fossils and these interesting magazines are often available at public libraries. Geology departments of museums can be very helpful, and of course the Geology Museum at South Kensington in London is a fascinating and informative place.

The collection should always be stored in wood or glass containers as tin can cause bad discoloration by rust. Large kitchen storage jars or square acid jars are ideal and make a decorative feature in themselves when filled with pebbles and covered with water to keep alive the natural wet colour of the stones.

Reds

Serpentine	(ovoid) The Lizard, Cornwall
Agate	(banded) Cromer, Aldeburgh, Felixstowe, Ramsgate
Carnelian	(translucent, horny, but often worn ovoid) Cornwall, Kent, Suffolk (Felixstowe), Norfolk (Cromer)
Jasper	(sometimes striped) most beaches
Sandstone	(ovoid) Norfolk, Kent, Dorset, Devon
Red slate	(fissile, lustrous, sometimes slightly crystalline) Devon, Cornwall, Wales

Browns

Jasper	most beaches
Chocolate stone	Harwich
Carnelian	(translucent) as for reds
Dolerite	(ovoid) East Coast, S W Coast
Chert	(angular, sometimes rounded) Kent, Dorset

Greys

Flint	(irregular) most beaches
Chalcedony	(fairly rare) Perthshire, Norfolk, Suffolk
Dolerite	as for browns
Schist	(fissile, shimmering lustre, flattened ovoid) North Wales
Onyx	(clouded) fairly rare
Chert	(irregular) Kent, Dorset
Granite	(rounded) Dartmoor, Cumberland, Cornwall, Scottish Highlands

Blacks

Jet	(lustrous gloss, irregular) Whitby, Felixstowe
Chert	(irregular) as for greys
Basalt	(irregular) Isle of Staffa, N. Ireland, many beaches

Oranges

Carnelian	as for reds
Smoky quartz	(crystalline) Cairngorms, Scotland

Blues

Blue shale	(avoid, round) Chesil Bank, many other beaches
Blue slate	(fissile) Ilfracombe, other beaches
Dolerite	Grey-blue, many beaches

Greens

Schist	as for greys, North Wales
Serpentine	(avoid) Cornwall, Anglesey
Jasper	as for reds
Greenstone	Cornwall

Yellows

Serpentine	as for reds
Carnelian	as for reds
Sandstone	Nofolk, Kent, Dorset, Devon
Smoky quartz	Cairngorms, Scotland
Citrine	(round, ovoid) Cornwall

Purples

Amethystine	(crystalline) Cornwall
Slate	as for reds
Jasper	as for reds

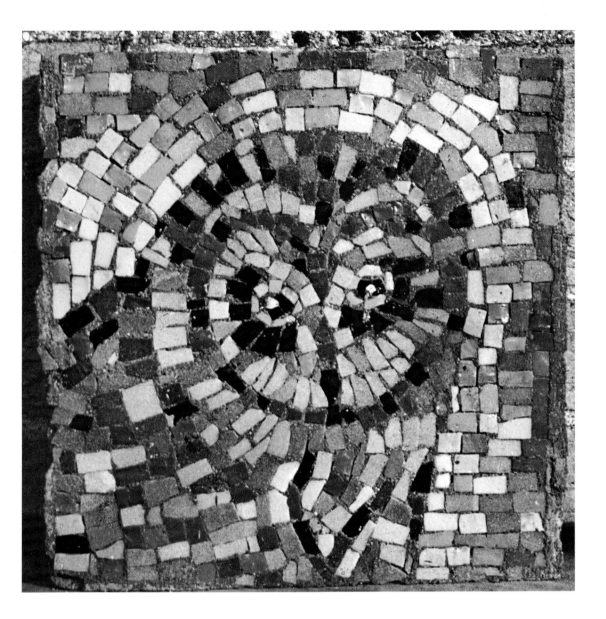

Owl of mosaic. See pages 54 to 58

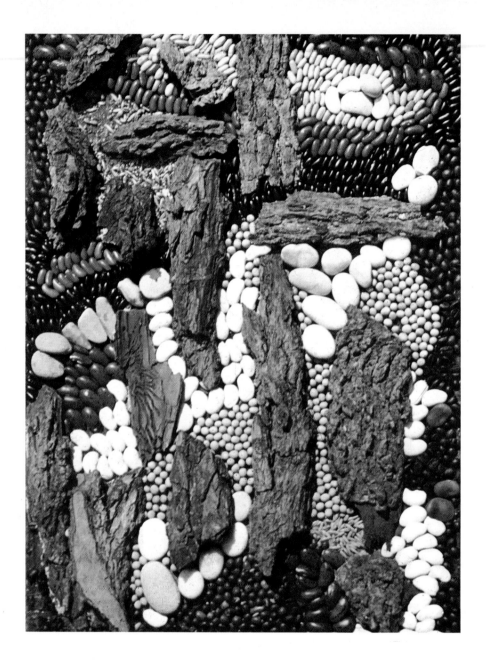

Seed mosaic by Helen Hutton

Pinks
Rose quartz	(crystalline) Cornwall
Agate	Norfolk, Suffolk, Kent
Sandstone	most beaches

Whites
Opaque quartz	Cornwall
Flint	most beaches
Chert	as for greys

MISCELLANEOUS

Ammonite Fossils

The Spiral Fossil, or Snakestone. These are generally dark grey but can be found in other shades, according to whether they are bedded in cliffs of limestone, chalk, shale or sandstone. Some are intermingled with crystals and others are covered with iron pyrites (fool's gold) and shimmer with a brassy lustre. They are more common than is supposed and can be found in quantities at Lyme Regis in the subsiding cliffs of blue lias, also in the East Cliff at Whitby, Hunstanton in Norfolk, Folkestone and quite a few beaches where the cliffs are limestone, shale or chalk. They are also abundant in many of the inland quarries such as those along Wenlock Ridge in Shropshire.

Pudding stone

This is a Conglomerate, a stone composed of tiny pebbles cemented together by some substance like silica. It is often very decorative when found in a dark shale, pebbles of white quartz scattered over the surface. Braccia is a similar stone but the fragments are usually more rounded. These are found at Torquay, but pudding stones of many varieties are found on most beaches.

Iron pyrites

This has already been mentioned as a brassy covering to ammonites and other fossils. In crystalline form it is an opaque metallic yellow, but is more commonly found as veining through another stone or on slate or coal. It abounds in Penrhyn slate quarries, North Wales, but can be seen in Cornwall, Dorset and on other coasts.

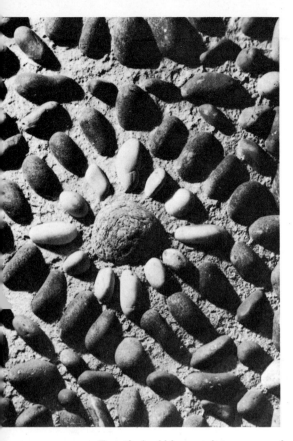

129 Detail of pebble mantelpiece surround

Mother of pearl

This covering can be found on ammonites at Folkestone in Kent, and is another very decorative surface.

Marble

This is obtainable from many quarries, but is more easily bought as chippings from monumental masons. White and other stone chippings can also be found here.

Several examples follow of projects carried out in pebbles, stones and flints.

PEBBLE-FACED MANTELPIECE
(124, 125) BY JOHN HAWARD

Materials

Stones and pebbles from the Cromer Ridge, Norfolk. Mortar

 1 part cement 1 part lime 4 parts sand

Method of designing

A free design of geometric origin adapted to fit in with the shapes and sizes of stones available.

Site

The mantelpiece panels of a fireplace in a Norfolk flint cottage.

Method of working

When sufficient stones had been collected—white, grey and reddish browns were used—a wood frame was placed round the area to be cemented and the mortar mix trowelled on. This mix was fairly dry, but not too dry to inbed the stones. The outline of the design was lightly scored into the mortar and then the stones were laid in, being gently hammered into place.

The three different motifs of the design could be done in three stages with different cement mixes, if sufficient stones could not be collected for the whole panel. In this case the edge of the finished panel should be thoroughly damped before the new mix is laid against it.

PEBBLE PAVEMENT MADE WITH PREFABRICATED MOULDS

This pavement was designed and carried out by people who have a cottage on the Norfolk coast, across the marshes from which lies a great shingle bank, famous for its stones and pebbles. As both the family and visitors had already made an interesting collection of these, it was decided to make them into a pavement which would thus provide a permanent situation for them.

The work was done mainly at the weekends and more pebbles were collected as required, as a very large selection is needed for a scheme of this kind.

The pavement was situated on a rectangle on the south-east side of the cottage.

Materials

Stones and pebbles from Salthouse beach, 50 mm (2 in.) diameter approx. oval
Mortar
 Sand, cement, hydrated lime

Tools

Ordinary mortar tools

Method of designing

This is worked out from a tile pattern in the Alhambra (Spain) and adapted to size for use as a pavement unit (131). The thickness of the moulds was based on the thickness of a brick.

Method of working

When the size, colour and shape of the pebble had been decided upon they were sorted into groups and piled in heaps on a long trestle table placed near the pavement construction. Although in this case many shades of pebbles were used, some may prefer to work in more contrast and use only black and white between the concrete moulds.

Construction of the concrete moulds

A template was cut in thick paper to the measurements as shown in the diagram (132). This was taken to a

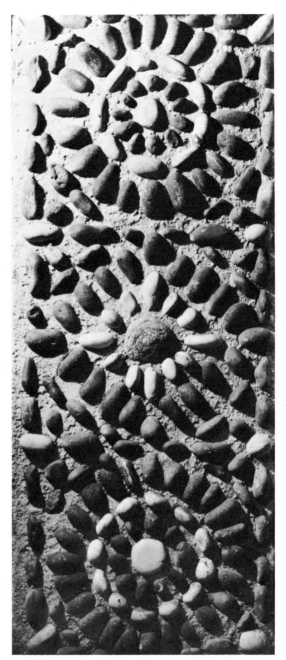

130 Mantelpiece surround

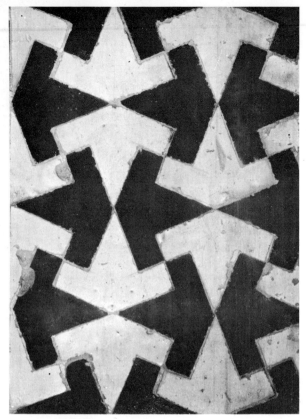

local carpenter who cut six moulds to the specifications in 63 mm (2½ in.) wood. A heavy wood tray was used as a baseboard, the wood moulds were placed on this and screwed down firmly by means of the wood and metal frame as shown (134) and the following mortar was pressed between the moulds:

3 parts sand 1 part cement

mixed dry, adding only sufficient water to bring it to a crumbly state. The approximate quantity needed for the two blocks was measured into a bucket using a small coal shovel as the measure. 6 heaped shovels of sand to 2 of cement were required.

This mixture was packed well down between the wood moulds as shown (135, 136), and then rammed closely in with a hammer, paying special attention to the edges. The moulds and the attaching frame were now removed and the concrete moulds on their base board taken to a cool place to set, this taking about 48 hours. They were covered with a damp cloth throughout. Note: although the quantity given here is sufficient for the making of two moulds, four or more can obviously be made if sufficient mortar is mixed and other baseboards available.

131 Alhambra tile design

132 Diagram of template mould

133 Diagram of template locked in place

134 Frame and moulds

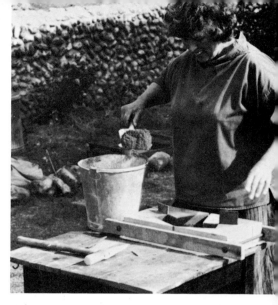

136 Cement packed between template mould

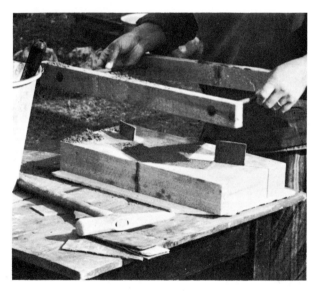

135 Frame being fitted round moulds

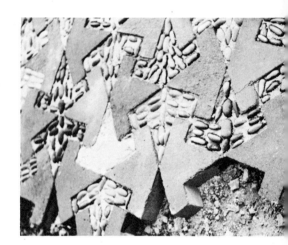

137 Pattern laying

138 Completed pavement

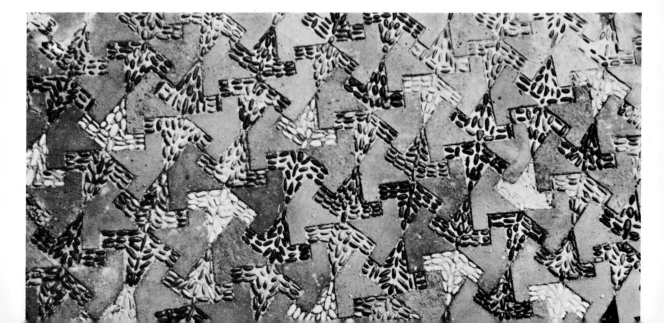

*139 Pavement in small bricks
in herringbone pattern*

Preparation for laying the pavement

The site was measured and then prepared by levelling and rolling to a firm level base. A thin layer of 13 mm ($\frac{1}{2}$ in.) gravel aggregate was laid on before the foundation mortar was spread, using the following mix:

1 part cement
4 parts sand
4 parts 13 mm ($\frac{1}{2}$ in.) gravel

This was levelled by drawing a board over and checking with a spirit level. After this the following mortar was mixed to bed down and fill in between the block moulds:

10 parts sand
1 part cement
2 parts hydrated lime

mixed to a rather wet consistency. The working time for this was about six hours. The concrete blocks were now placed in position four to six at a time, and checked for levels, using a little more mortar to bed them where necessary.

The spaces between the moulds were filled up with this mortar, using sufficient to bring them to almost the same level as the blocks, before ramming it well down. A little practice is needed in judging the right amount of mortar (depending on the wetness of the mix) so that the pebbles are embedded to roughly half their depth. They were laid according to their pattern as shown (137). Each one was gently hammered down as it was laid, bringing them all as nearly as possible to the same depth and finally as each unit was completed a board was passed over, as before, and pressed down. Any pebbles that persisted in projecting too high were hammered down again until the board could rest on a level with all the concrete blocks.

The area that was finished was left to dry normally, although in very dry conditions a sack could be laid over.

By this method a fairly large section was completed each weekend (138). Figure 139 shows another example of a pavement laid in small bricks in a herring bone pattern.

The range of materials for this type of work is quite wide and while it is possible to use very small seeds such as mustard, rice, lentils, wheat, pearl barley, etc., remember these will either have to be handled with tweezers or sprinkled on to glued areas and then pressed down. A fine variety of material may be found among the larger beans, butter beans, haricot, broad beans, coffee beans, dried peas and the many dried beans in varying colours to be found in the continental delicatessen, especially in Soho, London, or at any seed merchant.

The garden and countryside provide many interesting seed heads such as poppies, lilies, tulips, giant cow parsley, peonies, irises, and of course the countless seed forms from trees, acorns, sycamores, to mention only a couple. Seeds from vegetables and fruit should not be forgotten, pumpkin and marrow, melon, orange and lemon pips.

If this type of nature mosaic interests you, like the stone and pebble ones, it can give purpose and interest to country walks and to autumn days in the garden, even to the extent of growing plants and vegetables that will produce decorative seedheads or beanpods.

Children enjoy making this kind of mosaic and an example will be given of one made by the children of Cottenham Village College.

The general method of preparing the material for these mosaics is first to choose a varied quantity of seeds, beans, etc., separating those which will germinate or form a mould. These must be spread on an oven tray and heated for 15 minutes or so in the oven at a temperature of 250°–300°. They should be left to cool and then sorted into glass jars—jam jars or kilner depending on size and quantity—and stored in a dry place.

Bark is another material that combines well with seeds, or it can equally well be used alone. Choose as many varieties and shapes as possible with an eye to the different tones of colour that can be found. Willow is a greyish silver, while walnut and chestnut have browner tones, and some of the conifers have shades of copper red. Many of these barks have greenish markings of lichen and moss and though most of this will disappear when baked in the oven, sometimes a tinge of it remains.

As with the seeds it is equally important to bake the barks, as many of them harbour woodlice, and most of them need drying out before any adhesive can be applied.

Bark can often be collected from around the base of

Seed and Bark Mosaics VIII

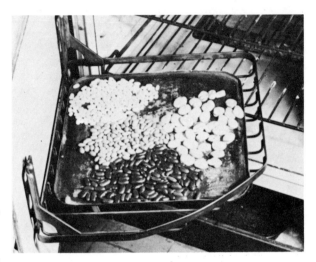

140 Seeds and beans being heated in oven

141 Pans of seeds and beans

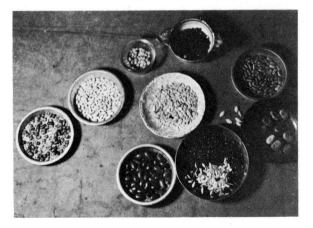

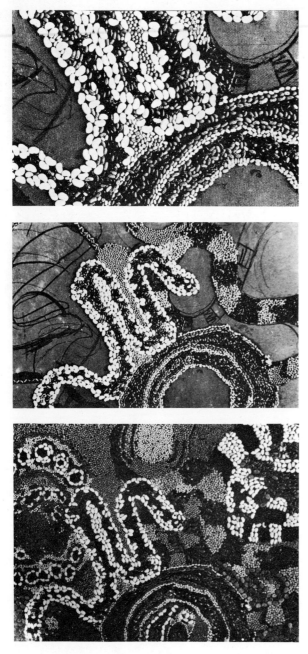

the tree or on the ground. If it has to be stripped off it is usually possible to find a piece that is loose that can be prised off easily. Some trees present long rectangular slithers, while others shed their bark in shorter sections.

When you are designing a mosaic with bark, never attempt to cut it or shape it, but break off sections along the natural cracks and allow the natural form to compose the design. It is, in fact, quite difficult to go wrong with the design of a bark mosaic.

The only equipment necessary is a pair of tweezers (if tiny seeds are being used) and a spatula or length of stiff cardboard for spreading the adhesive.

EXAMPLE I
VILLAGE COLLEGE SEED MOSAIC

The idea for the pattern of this came from photographs of snakes and snake skins. A large picture of snakes coiled up and intertwined gave the original idea of composition and various freehand drawing was done until a pattern was evolved that pleased everyone.

This was drawn on to the board with charcoal by the children (average age 12 years), nine of them working on it at a time.

Materials

Assorted seeds including beans, peas, wheat, melon
Evostick and *Copydex* adhesive
Hardboard, battened at the back for rigidity
75 mm × 100 mm (3 in. × 4 in.)
Cardboard spatulas for spreading adhesive

Method of working

The seeds were laid on to the drawn design on the hardboard, which was used on the rough side. Small areas of adhesive were spread at a time and the larger beans and seeds placed singly by hand. The smaller ones were spread in small handfuls and by hand gently smoothed across the adhesive. As a general rule the larger beans outlined the main forms, while the small ones were used to fill in the background.

The colours were white, chocolate brown, silvery green, and purple flecked with white (runner beans) with a few touches of greenish yellow brought in by the broad beans.

The illustrations will show the method of working and the final mosaic which was proudly set up on the walls of the class room (142–44).

142 and 143 Details of children's mosaic
144 Completed mosaic

EXAMPLE 2
BARK AND SEED MOSAIC

See colour plate facing page 93

Most of the materials used in this mosaic picture were collected in the countryside with the exception of a few of the beans which were bought at a grocer's—the coffee beans, the white butter beans and the dried peas. The wood panel that served as a base was an old disused drawing board that seemed to have a sympathetic quality in its grain and, indeed, although it was completely covered up in the end, the patterning of the grain served largely to inspire the design (145).

A random type of design seems the best to choose for this kind of medium, perhaps one that is vaguely reminiscent of the rolling hills, waving fields of corn, the wandering line of a brook and the occasional tall uprights of the trees. The textures used can echo this idea—the roughness of the bark with its broken uneven contours, the areas of strewn grain, smooth-sided stones and the many-surfaced seeds and beans.

The design was sketchily laid out and then viewed through a reducing glass (or the wrong end of field glasses) with frequent alterations of the various masses until the right kind of pattern seemed to emerge. None of the areas was glued down until the whole became a satisfactory design, although quite a few alterations were made as the work progressed and the idea became clearer.

Materials

A plywood board 13 mm ($\frac{1}{2}$ in.) thick
140 ml ($\frac{1}{4}$ pint) *Unibond*
230 g ($\frac{1}{2}$ lb) *Nic-o-Bond Thikbed*
Bark from willow, elm, chestnut and walnut

The following beans and seeds (quantities approximate)

100 g ($\frac{1}{4}$ lb) butter beans
$\frac{1}{2}$ dozen broad beans
100 g ($\frac{1}{4}$ lb) dried peas
100 g ($\frac{1}{4}$ lb) coffee beans (dark roast)
50 g (2 oz) of three varieties of french beans (white, brown and purplish-black)
50 g (2 oz) runner beans (purple and black flecked)
A few melon and pumpkin seeds, a mixture of wheat, oats, rice, mustard and spinach seeds
A few white pebbles

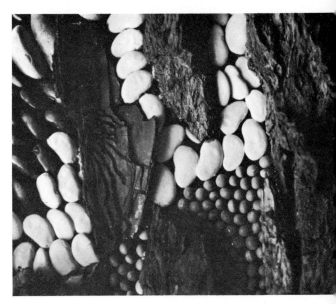

145 Mixed natural materials in random design

146 Plastic mortar spread into bark concavity

Tools
>A palette knife (for spreading the glue)
>A thin pointed vegetable knife
>Tweezers (generally necessary but not used for this work)

Method of working

The method of designing this work has already been discussed. The various materials were collected and selected, although it is a good idea to keep a fairly varied stock of bean seeds, stones, etc., for this type of mosaic. Even bark can be collected in any season and stored for a considerable time. Where there is any possibility of germination, the seeds and beans should, as stated before, be baked in an oven, although this often affects the colour.

STEP I

The larger masses, such as the bark, were first outlined with white chalk. As many of the strips of bark were twisted or concave it was necessary to trowel a layer of plastic mortar (*Nic-o-Bond Thikbed*) into the cavities so that they could lie flat on the board. When the baseboard itself is rather porous it may be necessary to apply a coat of fast-setting glue such as *Unibond* to the flat surface of the *Nic-o-Bond* when it has set hard.

STEP 2

The areas between the bark were now lightly sketched in with the chalk, often carrying the different textured areas across and beyond the bark so that the background became a unified mass and not just small areas filled in with different material. The colour, shapes and different surface textures (i.e. matt, glossy, rough, sharp or rounded) were carefully considered and placed in what seemed a right relationship to each other. As mentioned earlier, the unfolding pattern was constantly reviewed by peering at it through the wrong end of field glasses (or opera glasses).

STEP 3

The glue (*Unibond*) was applied when the areas were sketched in, covering only small sections at a time, owing to the fast drying nature of the glue. This type of glue has the advantage of drying completely transparent, so that although it may be difficult to apply it neatly at first, it is reassuring to know that it will dry quite invisibly. Where it had been decided

beforehand which seeds and beans were to be used in certain areas, a single sample was glued on first to see if it looked right, before the general glueing was done. Quite frequently, though, one gets the feeling of what is right as the work progresses. It is sometimes found that the best method is to lay all the material on the surface before glueing any of it down; this makes it easier to carry out any radical changes before you are finally committed to a design.

Coffee beans were used here with a few shiny black dwarf beans. Owing to their oily nature the coffee beans were very difficult to stick with any permanency and several rolled off when the work was moved for the photograph. They have a deep rich glow which no other bean has and seemed ideal for this mosaic, but on the whole would be better avoided for technical reasons. See colour plate for completed mosaic.

STEP 4

The final step in this relatively simple mosaic was to frame it suitably in natural wood. It is often considered necessary to varnish the beans and seeds on this type of work and sometimes they are sprayed with cellulose, but in this case the lively textures of the differing materials seemed better left alone.

Cock made in Bark and Oyster Shells

This is an example of a figurative representation designed and carried out by 11 year old children.

The bark was broken by hand into natural fragments. The rough texture was ideally suited to this subject which was carried out with fresh spontaneity. After the outline had been sketched in, the pieces were glued onto the hardboard with a quick drying plastic adhesive.

147 Cockerel in oyster shells and bark

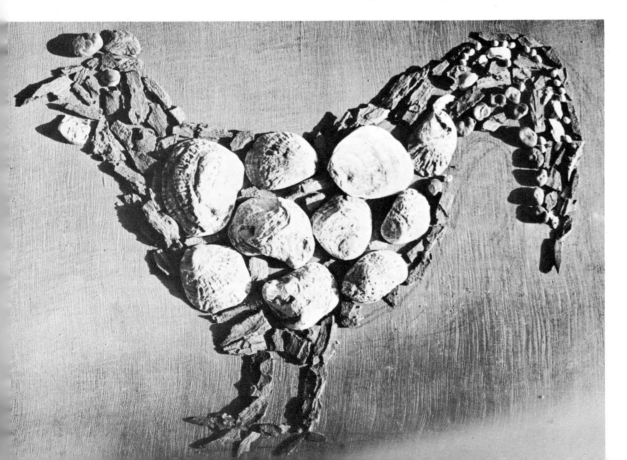

Types of Wood Mosaic IX

Another type of material which is available to everyone is wood in its many forms and textures. It is a sympathetic medium that may be used in large scale outdoor projects where it will mellow and weather to become an integral part of the natural scene, or as a more geometric mural indoors where it is sawn into small sections and used as tesserae.

For the outdoor mural or background to a patio it is better used in its original texture and colour, sawn only to workable sized units which can be as large or small as the situation demands. Indoors it may be used stained, or painted and sanded down again (gloss painted areas of wood are seldom successful), or simply in its natural tone and finish, although interesting mosaics have been made from unfinished softwood and highly polished veneers.

Timber merchants and sawmills always have a plentiful supply of waste sections of wood and will generally allow you to fill a small box with what you may require, free of cost. If, however, you plan to use different shaped sections such as triangles, or circles, it is best to buy lengths of the wood and cut thin sections from these, or get a jobbing carpenter to do this for you. A small power saw is the tool to use for this, as hand sawing is far too laborious and leaves the edges very rough.

An adhesive such as *Unibond*, *Evostick*, or *Bondcrete* is

148(a) Materials being assembled

generally used. If a rather thick base is required to bed down awkward shapes, sand can be mixed in small quantities with the adhesive alone or the adhesive added to a cement mix. As wood does not bond to cement, a good deal of adhesive should be added.

The wood mosaic shown (148(a), (b)) and described in the following example should give a broad idea of the method that may be used for most wood mosaics.

EXAMPLE

Materials

A wooden broom handle 25 mm (1 in.) diameter, cut into 3 mm ($\frac{1}{8}$ in.) sections

A wooden dowel stick 13 mm ($\frac{1}{2}$ in.) diameter, cut into 3 mm ($\frac{1}{8}$ in.) sections

305 mm (1 ft) length 25 × 25 mm (1 in. × 1 in.) softwood, cut into 25 mm (1 in.) sections

305 mm (1 ft) length 25 × 3 mm (1 in. × $\frac{1}{8}$ in.) softwood, cut into 25 mm (1 in.) sections

Several rectangles of 25 × 13 mm (1 in. × $\frac{1}{2}$ in.) oak, cut into lengths

2 squares of 75 × 6 mm (3 in. × $\frac{1}{4}$ in.) oak

A blockboard baseboard 455 × 255 × 6 mm (18 in. × 10 in. × $\frac{1}{4}$ in.)

Evostick adhesive

148(b) Completed mosaic by Peter Hutton

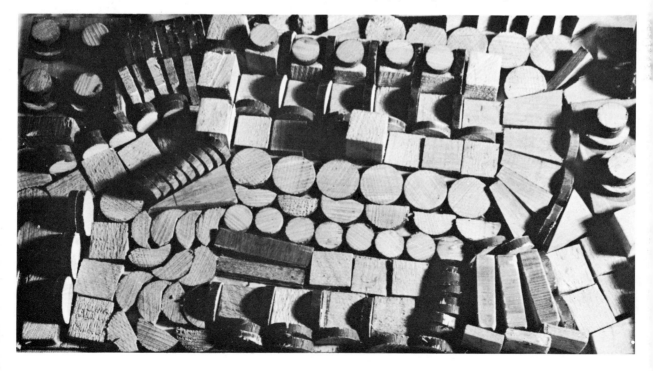

Method of designing

This was purposely confined to a few suggested lines, and as the wood pieces were brought on to the design it was altered considerably and the wood itself dictated the final mosaic.

Method of working

The wood sections were sandpapered down until the edges were smooth and all projecting splinters removed. The shapes were sorted into boxes and about one-third of the broomstick circles were split in half with a sharp chisel to form half circles.

Before the wood was glued on to the baseboard, certain sections of circles were glued together to form curved piles that would be finally laid down sideways, 'top hats' were glued together to be laid later on the 75 mm × 75 mm (3 in. × 3 in.) squares, but most of the wood was glued directly onto the baseboard. Extra glue was added to vertical sides that came in contact with each other, for extra strength.

Most of the mosaic was done in one evening and left to dry, a few final touches being added on the following morning.

This work was done by a boy of 12 and although some guide lines were drawn in on the baseboard, the majority of these were ignored and the final design was almost entirely his own idea of massing and grouping the small units into regimented areas.

Many variations on this type of mosaic will come to mind. The background can be painted in a deep rich colour such as prussian blue and the wood forms will be thrown into strong relief. Certain areas of the background can be painted in different colours, or stained with a wood dye. The sides of the wood sections can be painted or stained before being sawn. This latter will give a suggestion of colour to the edges only.

Larger wood sections to be used on more ambitious projects, such as a mosaic mural, can have the surface sanded into texture patterns and paint or stain worked over the areas by lightly brushing and sanding down again.

Several of these recipes for mortar mixes are to be found in the chapters to which they are relevant, but it may be useful to give a general summary of all of them here for easy reference, together with a brief description of some of the commercial adhesives and their properties.

The basic materials for mortar mixes are generally sand and cement.

Portland cement This may be bought from any builders' merchant and is usually sold in 50 kg (hundredweight) bags. It can be obtained in smaller quantities although it is seldom worth buying less than 6 kg (14 lb). This is generally sufficient for the mosaic artist as it has to be used while reasonably fresh, and *must* be kept dry and frost-proof or it will go off (lose its setting properties); so it is better to buy in small quantities rather than to waste half a sack.

Sand is also obtained from the builders' merchants and comes in two grades, silver sand and sharp sand. It must be kept dry and never used damp in a cement mix.

Hydrated lime In addition to making the mortar more workable, a small percentage added to the mix delays the setting time.

Ciment fondu A dark grey cement, more expensive than Portland. It creates a stronger bond, sets more rapidly and is static, i.e. does not shrink or swell. It is often used when a strong bonding mortar is required such as slab glass cement mosaics.

Cementone is a commercial colouring for all cement mixes. It comes in several shades, all of which are permanent. It is limeproof and stated by the manufacturers to be fadeless.

Sirapite The proprietary name for a quick hardening plaster. It is pink in colour but may be tinted with *Cementone*. It is very useful for small mosaics or work in schools as it is fairly cheap, but is unsuitable for exterior mosaics.

Polyfilla A small quick hardening plaster, white in colour but rather more expensive, as it is only sold in packets.

MORTAR MIXES, CARPENTRY

So many adhesives are now on the market—polyvinyl acetate resins, casein glues (some of which may not be water-resistant), plastic cements—most of which may be used for mosaics, but for the purpose of this book it is better to confine the choice to a few that have been personally used. Their trade names are given here.

Bondcrete and *Unibond* are excellent for all types of mosaics where an adhesive method is used. They are waterproof and easy to apply and may be the base for the Direct method when a mortar setting bed is not being used.

Evostick, Fixtite and *Richafix* are similar adhesives. *Bondcrete* and *Unibond* are used in small quantities to make a cement-mix bond on to glass and ceramics more firmly.

There are also ready-mixed grouts such as *Polygrout* and *Nic-o-Grout. Nic-o-Bond Thikbed* is a cement-mix of more substance which makes an excellent setting bed for tesserae of all thicknesses. It takes two to three hours to set.

Araldite is an epoxy resin glue which sets intensely hard and is usually employed to bond sheets of glass together for mosaic making. *Tensol* is also used for this purpose.

Basic mortar recipe (see page 34)
 3 parts sharp sand 1 part Portland cement
 $\frac{1}{8}$ part hydrated lime Mix fairly dry.

Grout recipe (chapter IV, the Owl Mosaic)
 8 parts fine sand 2 parts cement
 1 part hydrated lime
 Mix to the consistency of thick syrup.

Grout recipe (for filling papered sections in Reverse method or grouting Direct laid tesserae)
 5 parts Portland cement 1 part lime
 Mix to the consistency of cream and spread over the mosaic, working well into the cracks.

Foundation mortar (for pavement laying)
 4 parts sharp sand 4 parts 13 mm ($\frac{1}{2}$ in.) gravel
 1 part Portland cement
 This should be laid to a depth of 38 mm ($1\frac{1}{2}$ in.)

Mortar recipe (for bedding pavement units and filling between) 10 parts sharp sand
 2 parts hydrated lime 1 part Portland cement
 This mix should not be too dry.

Putty for glass mosaics (translucent type page 80)
 3 parts whiting 1 part *Sirapite* (or plaster of Paris)
 Lamp-black powder to mix to a dark grey-black
 Linseed oil to mix to a dryish paste
 Turpentine (sufficient to further moisten to consistency of putty)
 This putty is worked into the cracks between the tesserae.

To mix plaster of Paris (for plaster batts, etc.)
 For a hard mould
 The plaster is mixed by adding it to water at room temperature and *never* by pouring water on to it. 18 parts of plaster to 9 of water

For a simpler method, without any measuring, half fill a bucket of water and add handfuls of plaster until the water is saturated and a small mound of dry plaster rises above the water, disappearing after a few moments. The mixture should then be mixed slowly by hand or with a wooden stick, allowing no bubbles to form, until it is of an even consistency. Pour this into a wooden frame if required for a batt. Clean bucket immediately.

PREPARING NEWLY-DUG CLAY

Collect a quantity of clay and place in buckets of water for moistening. Press the slopped-down clay through a fine 80 mesh sieve several times with the help of stiff brushes. Siphon off water until clay is workable. It should be stored for maturing and then subjected to further treatment of kneading by hand. It must be worked in this way until it is homogeneous and free from air bubbles.

WATERPROOFING

Water glass brushed over chipboard of 13 mm ($\frac{1}{2}$ in.) plywood (thinner wood will warp unless battened) in a fairly strong solution is an adequate means of waterproofing backing boards for mosaic. Shellac can also be used for this purpose.

WOODEN FRAME FOR SETTING MORTAR IN

For the average small mosaic a frame made of 50 × 25 mm (2 in. × 1 in.) plain softwood is suitable. This simple frame is hinged at one corner and fixed with a small hook and eye at the opposite corner. This makes it possible to open the whole frame outwards after the mosaic has been finished without disturbing the edge of the cement or plaster base. The larger mosaics will need more substantial wooden framing, as the essential thing is that the wood shall not bend when the plaster is pressed down into the frame.

FLOUR AND WATER PASTE

Combine 25 gms (1 oz) flour with 125 ml ($\frac{1}{2}$ pt) water and mix to a smooth paste. Bring to boil and boil for five minutes, stirring constantly to avoid lumps. Cool and use to stick tessera on to paper for the Reverse method. The paper is easily removable when damped.

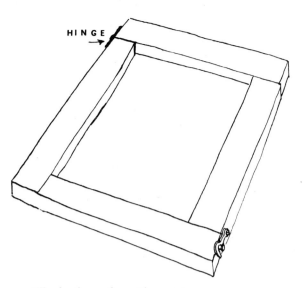

149 Wooden frame for setting mortar

Historical Background XI

This section is a brief survey of the main phases relating to the development of the art of mosaics from the earliest techniques to those of today, their application and aesthetic impact over five thousand years. From the simple Greek pavements in two-tone designs, the most persistent and invariable trend has been the embellishment of architectural surfaces. It can be assumed that mosaics have always been regarded as a high art form from the fact that the actual word derives from the Greek 'Muses'.

Basically it is carried out by the application of small fragments of stone, ceramic or glass of roughly uniform size, shape and thickness called 'tesserae', set on a surface that can be vertical, horizontal or curved. These tesserae cubes, though usually of such material as marble, stone, glass, shell or pottery, were sometimes of large plaques of stone or marble set into a recessed surface. In some of the earliest works, pebbles and conical clay pegs were used.

Mosaics have been used to decorate both small and vast areas of buildings on the interior and exterior as may be seen in the domes and on the floors of the great basilicas of old and the façades of contemporary cathedrals and civic buildings.

Over the centuries between the Sumerian period and the present day, the methods of applying the tesserae have varied to some extent, although the basic sequence of operations as practised in Greek and Roman times has usually remained a standard procedure. The tesserae were the elements which were built up following a pattern or image, into a coherent mosaic design, integrated into an architectural setting. On a technical level, the usual preliminary steps were as follows.

First, the surface to which the mosaic was to be applied was roughened to provide good holding for the first layer of mortar—more essential for walls than floors as it had to key on and not slip downwards. This layer was scored and pitted while still damp to provide strong attachment for subsequent layers. Sometimes several more layers were applied before the final layer of plaster, which would receive the tesserae, was laid on. This was approximately the same thickness as the tesserae to be used. It was smoothed and the design of the planned mosaic either traced or drawn directly onto it, or, more often, painted in freely with a brush. The coating was scored and chipped and a setting bed applied over small areas, following the design lines and covering only enough to set the tesserae on before the plaster set. Each tessera was pressed onto this

damp base, working from the top downwards. At a later stage a tinted plaster grout (infilling between the tesserae) was sometimes used so that the design would not become confused by an inter-crossing of white lines caused by the plaster base. Inevitably a certain amount of tilting and angling occurred through this method of individual setting-in of each tessera, and this gave the typical reflective glitter and liveliness that was lost in later centuries when technical skills produced near perfect flatness.

Sumerian works in the ancient city of Uruk (near the present site of Erech in Iran) is the oldest known mosaic decoration prior to the pebble designs. This was a frontage of about 25 m (80 ft) long, composed of conical clay pegs, between 38 and 152 mm ($1\frac{1}{2}$ and 6 in.) long embedded in mud walls and columns, their coloured heads reinforcing and decorating in geometric designs of black, white and red. The probable date of this was about 3000 BC. The adhesive was presumably bitumen, which was one of the earliest known; it was obtained from a natural seepage through the earth and when combined with sand formed a strong type of asphalt.

Other early examples dating from c 2600 BC sited at nearby Ur may now be seen in the British Museum, London. They include a Sumerian object of unknown purpose with figures cut in shells surrounded by lapis lazuli, limestone and shell, and also a restored Sumerian column from El-Ubaid, Iraq, originally a palm log covered with thin tesserae, square and wedge-shaped made from black bituminous limestone, white mother of pearl and pink limestone. This three-colour scheme was typical of Sumerian work. Here the tesserae were fastened by copper wire to a base of bitumen, some of which oozed up through the joins emphasizing the separation of the units which was a basic feature of these mosaics.

The clear cut type of mosaic of the Sumerians fell into disuse and oblivion. Common pebbles took over as a medium and although a simple one, proved to be very effective; black and white stones were used in both abstract and figurative designs, the black being used for background and the white for figures or pattern areas. Occasionally red, green, grey and purple pebbles were also used, one of the finest examples of this work being the Lion Hunt at Pella, the capital of the empire of Alexander the Great (300 BC). Here, it appears, was one of the first centres in antiquity to develop this technique of pebble mosaics. The small water-worn stones in several colours were

150 *Typical Roman border designs of fret and triangle*

strengthened in outlined form by embedding strips of lead on edge into the mortar.

The transition to regularly shaped tesserae took place between the third and second century BC and developed from the roughly shaped sections of stones or chipped pebbles to fragments of standard dimensions with a level face. As technique improved, floors assembled from these gradually became flat and even and were then ground and waxed to reveal the colour of the stones. Eventually the mosaic palette was no longer restricted to the muted tones of pebbles but was able to range among the shades available in marbles, rocks and semi-precious stones.

The transformation into the more precisely cut cubes was completed in the maturing of the magnificent mosaics on the island of Delos—of uncertain date but probably from the first half of the second century BC. Considerable elaboration had now been attained, and the secret behind the dazzling display of colour was the fact that together with the various marbles and semi-precious stones such as onyx and agate, smalti of coloured glass paste were introduced for the first time. At first they were used sparingly to brighten duller areas of natural stone but were soon to become the mosaic material par excellence. Produced by a fusion of sand and mineral oxides, they took the form of brilliantly coloured cubes.

During the second century BC an important development took place on the island of Pergammon, which became the natural centre for the production of this type of tessera. New techniques for the manufacture of smalti originated by the superimposing of one colour onto another to create an intermediate shade. Brilliant reds were obtained by applying a translucent coat of red plaster to white tesserae—a similar procedure later becoming the standard practice in the manufacture of gold smalti. As the tesserae became more minute, designs of infinite detail and delicacy were possible. The mosaic artist was able to conceal the fact that the work was an assemblage and this, unfortunately was the first step towards a perverse perfection.

At about this time a famous mosaicist emerged, Sosos of Pergammon, and one of his existing compositions, the 'Unswept Floor' (Vatican Museum), is a superb piece of illusionism. Equally famous, and of similar naturalism, is the 'Pigeons Drinking' (also in the Vatican Museum). Both of these have been widely copied and ultimately were spiritualized into Christian iconography. Considerably later copies of these

works, probably of the second century AD, were discovered in Hadrian's Villa, and these may now be seen in the Capitoline Museum in Rome. Pavements in a similar style have been found at Delos where a strong theatrical tradition prevailed. Famous actors from all over Greece performed here as the many mosaics representing their dramatizations reveal, some of these records going back to the first century BC.

Alexandria was an important cultural centre during the second century BC, and with their conquest extending into the east, the Romans were exposed to all the exotic influences that prevailed there. They came to admire the luxurious life style and flourishing arts of the Grecian princes, and the tradition of mosaic was the one they most greatly favoured. Some of the finest figurative mosaics found in Pompeii were of Hellenic inspiration. Now that many of these are on display on the walls of the National Museum in Naples, they are easier to admire and study than when they were in their original setting. One of the most famous of all classical mosaics 'The Battle of Alexander and Darius' from the house of the Faun in Pompeii is to be seen there and the derivation from a Greek source is very apparent. The dramatic battle scene described with accuracy and intricacy in various shades of only four colours—black, white, red and yellow—is obviously inspired by a painting. Despite various speculations, the artist remains unknown.

The most modest mosaic type of floor (opus signinus) was a levelled surface made from odd fragments of stone or pottery of different colours, set in at random rather like the currants in a cake. Some of these may still be seen on the footpaths at Pompeii— mosaics set in a plain all-over pattern, repeated endlessly from wall to wall. The predominating themes were the key, wave crest, cable, overlapping shells, fret and triangular border patterns (150 and 152). One of the mosaic floors at Fishbourne Roman Palace, Chichester (151) incorporates many of these elements in design.

The Greeks developed these patterns more imaginatively, giving their creative powers more scope by designing floor layouts for specific areas. The composition of these was more usually in the form of a medallion, enclosing a scene or a figure as the central motif. This was surrounded by bands of abstract or floral ornament. The centre pictorial insert was known as the *emblema* (plural *emblemata*). On very large areas the thematic medallion might be repeated

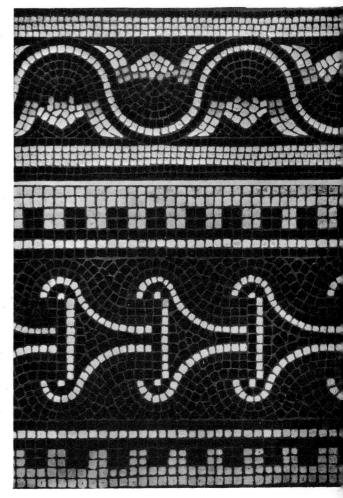

151 *Roman mosaic*

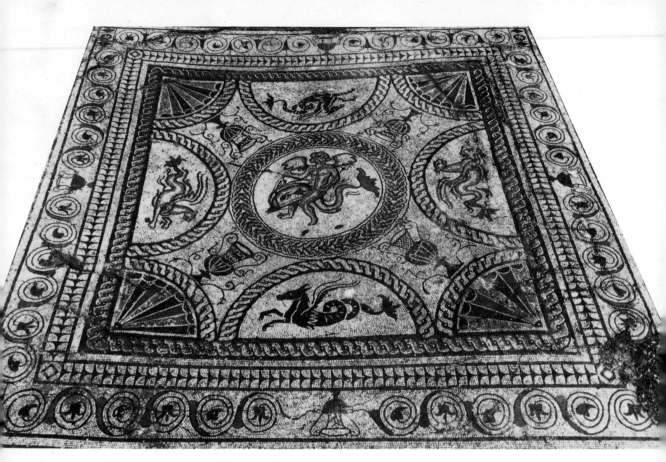

152 Roman mosaic floor (Courtesy of Fishbourne Roman Palace)

with variations, such as a series of the signs of the zodiac. Templates were used frequently for laying in backgrounds and borders and fairly coarse tesserae, frequently 13 mm ($\frac{1}{2}$ in.) square, were used. These were set in straight or curved lines according to the motif followed. The pictorial portions, however, were set in a more intricate and flexible manner known as 'opus vermiculatum'—literally 'worm-shaped work'. Minute tesserae, often of irregular shapes were used for this and the technique for setting them was not to a mechanical system but arranged to follow the forms of the figures. Medallion work of this kind is thought to have been carried out separately by specialists in a studio, as some of these inserts have been found, still mounted, on the shallow tray of terracotta embedded in the pavement. The fact that these pictorial inserts sometimes had raised edges leaves little doubt that the emblemata had been done separately—possibly the first examples of the indirect method. It is not known for certain when this method was introduced. This appears to be a problem that art historians have not

tackled but it seems likely that it was not used extensively until the nineteenth century when it was carried out in the workshops of Antonio Salviati.

There is, however, clear evidence that emblemata were portable and towards the end of the first century BC. According to Pliny 'paved surfaces were driven from ground level and moved upwards to vaulted ceilings of glass'. This reference to glass bears witness to the fact that smalti were used to a larger extent on walls than on floors in early Roman times.

The outstanding Roman achievement was the black and white pavement although it was introduced initially for reasons of economy. During the first century mosaics became so popular as a floor covering that there was need to discover a less expensive type, and a solution was found by reducing the numerous colours to a severe contrast of black (basalt) and white (generally marble or limestone—although marble was not used in any quantity until the fourth century). The distinctive style of the black and white mosaic is seen at its best at Ostia, the harbour town near Rome which was a flourishing port at that period. It is here that the tessellated pavements outside the shipping firms display marine motifs such as ships, fishes and exotic sea life, and here they may still be studied as the finest distillation of this style, a limited but more disciplined form of expression and a clear imprint of a Rome that was no longer dependent on Greece. The style predominated in Italy until the third century AD.

An interesting outcome of the black and white mosaic was the exercise in perspective and the various optical illusions made possible by the abstract patterns. A general freedom of style took over and the designs, no longer confined to the central emblemata, expanded over whole floors. During the second century the fashion for these geometric motifs in black and white flourished—key patterns, three-dimensional squares and lozenges giving effects in deep perspective (153 and 154). Fine examples of this work may be studied in the British Museum in London.

The latter part of the second century was, in fact, a period of great activity with the increase of new mosaic workshops inland in addition to those sited around major seaports. The popularity of polychromatic work retained its hold throughout many of the provinces, especially in southern France although the geometric idiom predominated in northern France, Germany and Spain.

There is no clean break apparent between classical

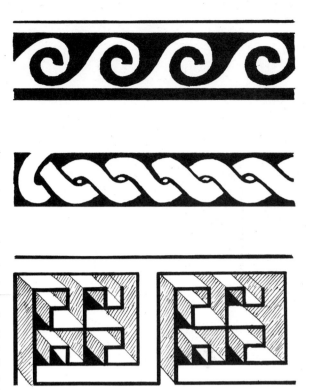

153 *Typical Roman border designs of wave crest, cable, and perspective effect of double meander*

154 *Second century geometric design in deep perspective*

155 Cross section of a typical Roman pavement
foundation showing build-up of layers
 1 Natural soil
 2 'Statumen'—rubble bedding
 3 'Rudus'—coarser mortar
 4 'Nucleus'—fine key layer in which
tesserae are embedded
 5 Inset tray containing 'emblema'
 6 Surface of 'emblema'
 7 Surface of mosaic

Roman and medieval Christian tradition. The transition was evolutionary rather than radical despite the change in religious bias. The Church of St Constanza in Rome is a monument illustrating the merging of the two ideologies. The vault sections are divided into circular or rhombic panels; that some are in the style of Roman floors is clearly evident, while in others the multi-coloured plants, birds or scampering putti are in obvious pagan homage to Dionysos. The Christian imagery in the lateral apses is dubious, but there is Christian evocation in the dome mosaic. This is a fascinating building to visit and to study—of the period AD 337–350.

As classical antiquity and the faith in the old gods faded, Christianity with its new moral doctrines opened up a golden age for mosaics. Golden in the literal sense also as vast murals composed of tesserae in gold and silver provided backgrounds which reinforced and reflected the glorification of the new religion. At first the classical forms and styles were unchanged but were forced into the role of serving another god—as in the example of S. Constanza—both royal and religious.

The change was gradual however; the imagery was no longer purely decorative but became propaganda for the new faith. The mode of presentation was dictated by this aim—idealization superseded representation. The apse of S Pudenziana in Rome (reproduced as the frontispiece), dating from around AD 400 and once a fine example of this period of transition has undergone continual alteration, repair and restoration so that it now is a bastardization of the original.

The Roman occupation of Britain took place during the middle of the first century AD, and although essentially a military outpost, stone masons were working on the cutting and polishing of stone for the panel inlays which preceded the floor mosaics of the second and third centuries. At Fishbourne Palace in Sussex, the recently discovered floor mosaics date from the end of the first century and have apparently been laid by craftsmen imported to Britain for that purpose. Only about a quarter of the original sixty floor mosaics are visible today. They may be divided into two types of which the larger group is dominated by black and white geometric motifs with the occasional introduction of colour or floral detail. The smaller group consists of floor mosaics of the polychrome type with more refined ornament of an architectural quality depicting imitation braided rib-

bon. At a later period during the second and third centuries, a series of new floor mosaics were laid at Fishbourne, and some still remain in such a perfect state of preservation that it is possible to study the technical details. (The diagrams (155 and 156) show a typical Roman pavement and a selection of central and corner motifs.)

Although these are probably the richest and most comprehensive examples of Roman mosaics in Britain, there are several other interesting sites where pavements, some quite recently excavated, may be seen. A very fine one is at Woodchester in Gloucester, a circular pavement depicting Orpheus and his lute, but as this is in a very fragile condition it is only uncovered every ten years. An excellent replica has just been made and is on view nearby in a disused church at Wooton-under-Edge. Several pictorial pavimental mosaics which have been removed from their original sites are in the Corinium Museum, Cirencester, and in the adjacent village of Chedworth a Roman villa lies at the head of a small valley. In an excellent state of preservation, the floor mosaics in the various bathrooms are of geometric design, composed of local stone, skilfully laid. The dining room is of fine pictorial design in near perfect condition. Two examples of the triangular inserts of the Seasons are illustrated (157 and 158).

With the departure of the Romans from Britain in the fifth century, the art of mosaics faded into oblivion in the country for fourteen hundred years.

In Ravenna, a cultural crossroads on the Adriatic, the Hellenic tradition continued to flourish although the city was still in the hands of the Goths when the building of St Vitale took place in AD 526. The mosaics in the chancel of this church are an outstanding example of concept and technique. The panels of Emperor Justinian and Empress Theodora are rich and majestic, and bear the strong imprint of Byzantine stylization, yet they show signs of a more humanistic naturalism; some of the faces are obviously portraits, while others are mere stereotyped masks. A wealth of subtle tones brings naturalism to the portraits while the elaborate head-dress of Theodora, composed of gold and green smalti, mother-of-pearl disks, and the turquoise-tinted earrings, bring haunting overtones of iconography.

The Mausoleum of Galla Placida (AD 450), reputed to have the oldest mosaic in Ravenna, has a mural representing figures which are still Roman in realism, but are placed against an indigo background charac-

(a)

(b)

(c)

(b)

(e)

(f)

156 a Chequer board
b Braided knot
c Swastika pelta
d Lozenge
e Scallop
f Pelta

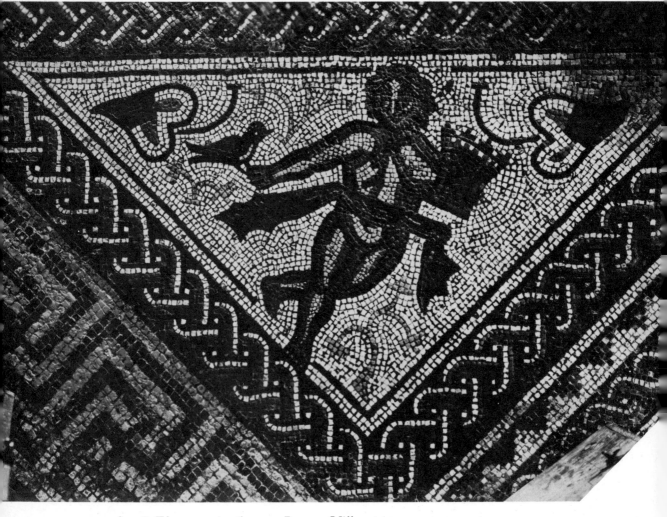

157 and 158 Floor mosaics from a Roman Villa at Chedworth, Gloucester. Figure of 'Spring' from West wing, Dining Room, and 'Winter' from the North Corner panel in Dining Room (Courtesy of George Roper, Cirencester)

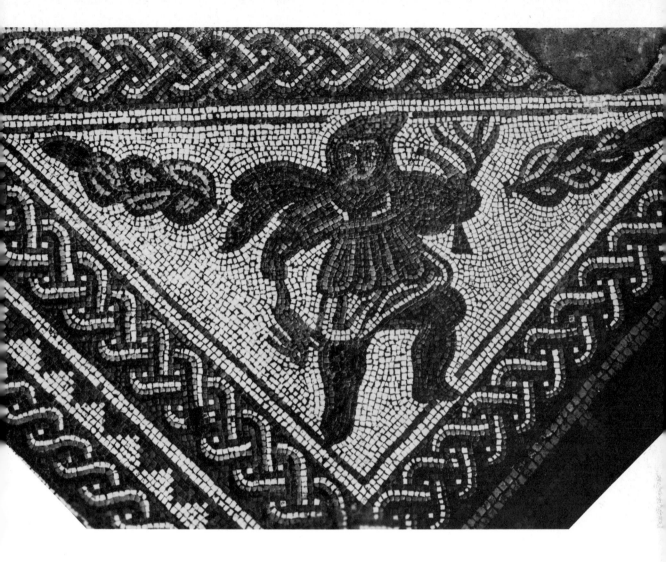

teristic of early Christian work—the blueness symbolizing sublime infinity which envelops the subject in profound mystery. Other mosaics of note which should be seen are in the Basilica Apollinaire, once known as 'the church with the golden sky' and S Apollinaire in Classe which is just outside the city. This church has a highly decorative apse mosaic depicting the saint surrounded by realistic animals and trees in a landscape of small objects, which display essentially Byzantine style and iconography. Although many of the finest works have not survived, Ravenna still possesses a remarkable number of monuments exemplifying the development of mosaic technique. They demonstrate the fusion of Roman, Barbarian and Eastern influences for over 1000 years.

An outstanding example of Islamic mosaics is Jerusalem's Dome of the Rock built by Caliph Abd-al-Malik in AD 685–705, its vast scintillating interior being covered with mosaics in blue, green and gold interspersed with small sections of other colours. The succeeding Caliph, Al-Walid, (705–15) commissioned Byzantine artists to carry out pictorial mosaics in the Great Mosque in Damascus. These works which were re-discovered in 1930 are flamboyant in style, and represent classical and eastern buildings reminiscent of the last stages of Pompeian wall paintings.

Islamic art in this field did not continue the traditional path after AD 900 but branched out into related techniques based on the early oriental tradition of ceramic tile work. These small, flat tiles, laid to form an even surface, did not reflect with the same glitter as the glass smalti; they were designed in varying geometric shapes and were predominantly blue and turquoise in colour. North Africa and Spain developed their mosaic tradition along these lines (as may be seen in the Alhambra) and this trend eventually extended as far abroad as India.

In 986 mosaic art reached Russia from Constantinople through the Grand Duke Vladimir of Kiev who married a Byzantine emperor's sister and invited Greek mosaicists to his city. Their masterpiece finally emerged as St Sophia, which was begun in 1043 under Yaroslav, Vladimir's successor, and consisted in an assemblage of smalti that were mainly manufactured locally. In fact the only churches in eastern Europe to acquire Byzantine mosaics were those in Kiev, with the possible exception of St Vitus' Cathedral in Prague where the façade, not the interior, was decorated in a coarse, provincial style, original and impressive nevertheless.

In Constantinople (Istanbul) there are surviving mosaics which were produced over several centuries but not with consistent continuity. Portraits of succeeding sovereigns, they tended to be stereotyped and rigid in posture. 'Christ in Majesty' is, however, a superb work carried out in the latter part of the twelfth century in Hagia Sophia. This was uncovered as late as 1933 and presents a hauntingly sensitive portrayal of John the Baptist. In this mosque the mosaics had been plastered over and on the new surface later murals had been painted by Turks during the occupation of the fifteenth century. Their discovery and disclosure has been an exciting, rewarding task for art historians and technicians, and is still proceeding.

Other interesting works of note completed during the twelfth century was in some of the smaller churches such as the aspidal decoration in the cathedral on the Venetian island of Torcello.

As technical skills increased, the ability to reproduce oil and fresco painting took precedence over mosaic design. An example of the over-decorated and ornate work of this period is seen in the apse of St Maria Maggiore in Rome. The designs were created by individual artists and the actual work carried out by craftsmen. About 1300 Cimabue was commissioned to undertake the mosaics in Pisa cathedral. The head of St John in the apse is considered to be the work of this artist and it is possible that his pupil, Giotto, may have contributed to his 'Navicello' mosaic (1298) depicting Christ walking on water. Only a distorted version survives today. Rather later, Titian, Tintoretto, and Veronese were among the artists designing cartoons destined for St Marks in Venice. These have been so extensively restored over the centuries, that what is seen now is a medley of styles of variable qualities. It is, however, an inviting place to study these techniques at close quarters, as the Golden Basilica is eminently accessible. In Florence, the mosaics to be seen in the cathedral are carried out from designs of Ghirlandaio.

As the influence of painting over mosaic gained momentum, the dominance which the latter had held in the field of art for over a thousand years began to weaken. Confusion between the two led to an artificial naturalism, the strong stylization which had characterized mosaics gave way to a meticulous, realistic imitation of painting. As an art form, mosaics faded out of the civilized world for nearly five hundred years.

The Vatican's smalti factory, which flourished over the centuries, continued to produce great quantities of tesserae and at this stage were manufacturing smalti in at least 2800 shades, encouraging mosaicists to re-create facsimilies of the works of the famous artists of the day.

The decline continued, however, as the imitation of painting went on. The Vatican workshops began to accept commissions to reproduce copies of classical works for wealthy patrons who required something permanent and durable and were prepared to pay for it. In St Peter's, Rome, there are copies of a Raphael painting which are such an incredible transcript from the original as to be indistinguishable from it.

Other countries became interested and mosaic workshops were established in St Petersburg in Russia and by Napoleon in France. The floor in the Melpomene Room at the Louvre was carried out by an Italian, Francesco Belloni, and his assistants in the classical, allegorical manner.

The Salviati workshops, founded in Venice in the 1960s, played an important part in the commercialization of mosaics by popularizing the indirect or reverse method of laying the tesserae. Dr Antonio Salviati, in collaboration with Lorenzo Radi, a Murano glassmaker, is believed to have introduced this method of setting the tesserae on a portable base of paper or cloth and by pre-assembling it in sections, enabling a complete mosaic to be transported to the site and reassembled in situ. Inevitably, this technique produced a surface flatness which lacked the scintillating qualities of a mosaic laid directly by hand and set at variable angles. However, it was a more commercially viable method and vast quantities of pre-assembled mosaics were shipped abroad to be put together by craftsmen on the site. The Albert Memorial in Kensington Gardens, London, is an example of this technique. Similarly the Wagner workshops in Berlin increased the popularity of the method by faithfully translating cartoons into mosaics.

Other mosaic artists who adapted to this method were Einer Forseth, a Swedish artist who designed a large mural for the Golden Room in the Stockholm City Hall, (1921–3) and Boris Anrep, a Russian trained in Paris, who designed the floor of the National Gallery, also Westminster Cathedral and the Tate Gallery in London. He designed and with assistants carried out his own work which was basically Byzantine in its stylistic derivation.

Several major modern artists adapted their work to

the medium of mosaics, the most successful one being Gino Severini, a disciple of Futurism—this movement proving the ideal form of expression for the medium of tesserae. Other artists whose work was interpreted into this medium were Braque, Leger, (mosaic on the façade of the Church of Our Lady, d'Assy, France) Bazaine, (mosaic above the entrance of the Sacred Heart Church, Audincourt, France).

Two other artists who made significant contributions in this field were Gustav Klimt and Antonio Gaudi. Both were influenced by the Art Nouveau movement. Klimt, who designed during the period of the Vienna succession, was inspired by a visit to Byzantine orientated Ravenna in 1903, and he assembled a mural decoration in Brussels composed of smalti, patterned tiles and preformed ceramics combined with painted sections. In a sense more a collage than a mosaic, it marked a freedom of vision and approach which unfortunately he pursued no further. Gaudi, on the other hand, went considerably further; also influenced by Art Nouveau, he coated the exterior of the buildings that he as an architect had designed, with a skin of weirdly assorted fragments. Sections of glass bottles, china plates and polychromatic ceramic tiles created an Arabian Night fantasy, unique and original, but also of practical value, coming at a time when both labour and materials were an expense to be considered. He exploited the possibilities of decorating vast surfaces with cheap or valueless materials which he used in larger sections than the standard tesserae. His outstanding works in Barcelona are the serpentine benches in the Guell Park and the decoration on the façades and spires of the Sagrada Familia cathedral, which are covered with large ceramic units, brightly coloured with a jade blue-green predominating, possibly inspired by the mosaics of pre-Columbian America. Sagrada Familia dominates the flat scene of Barcelona, its brilliantly encrusted spires rising and shimmering above the city, and presenting different forms of moulded organic shapes and triangular flat planes, all reflecting angles of light. Gaudi's contribution to twentieth century mosaic is outstanding and original.

In Mexico, with its dry climate, colourful mosaic murals stemming from the traditional pre-Columbian mosaic art of Teotihuacan, Toltec, and Maya, developed and thrived along contemporary lines. Many of these were on a massive scale on public buildings as labour costs were sufficiently low to release money for

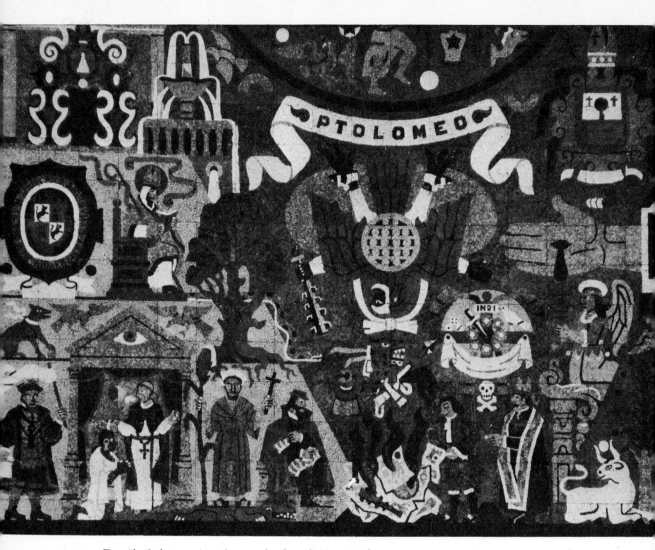

159 Detail of the mosaics of natural coloured stone on the south wall of the Library of the University City of Mexico, designed and executed by Juan O'Gorman (1950–51)

160 Relief mosaics in natural coloured stone at the Hotel 'Posada de la Misión' in Taxco, State of Guerrero, Mexico, by Juan O'Gorman (1962)

Figures 159, 160 and 161 reproduced by courtesy of Juan O'Gorman

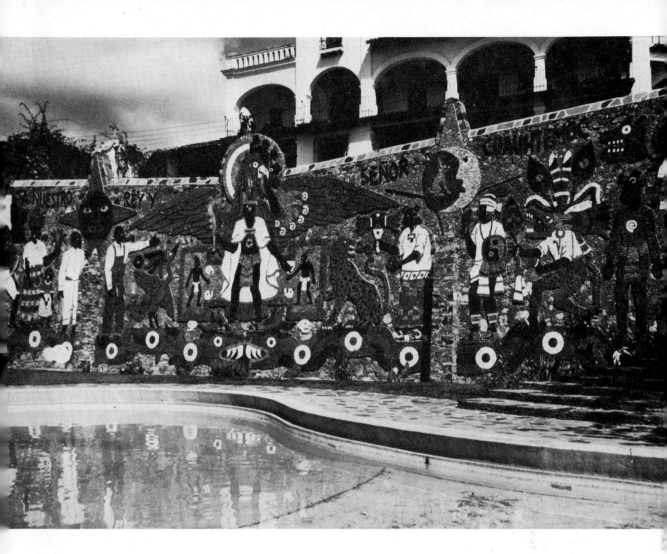

the materials for such projects. Diego Rivera was one of the leading mosaic artists of this period who handled the medium sensitively and grandly, continuing Gaudi's principles of whimsical originality. His finest achievement is his mosaic environment outside Mexico City Waterworks; carried out in natural stone in various shapes and colours, it depicts the rain god, Ttaloc.

Continuing this powerful trend, other Latin-American artists produced works expressing, as they termed it, 'social realism' and so promoted a revival of mosaics as a socially interpretive medium. Juan O'Gorman designed an immense mural of approximately 385 sq m (4000 sq ft) to cover the walls of the library block at University City in Mexico. (See details in illustrations 159, 160 and 161.)

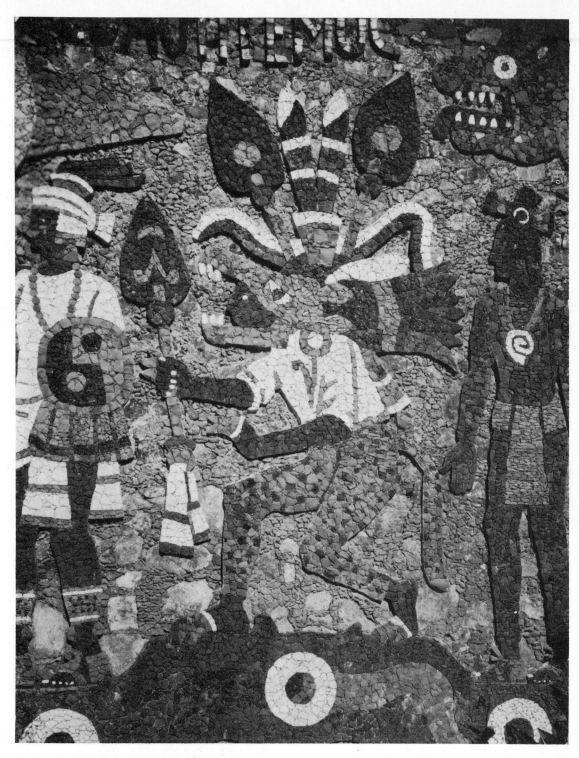

161 Detail of relief mosaic in natural coloured stone by Juan O'Gorman (1962) at the Hotel 'Posada de la Misión' in Taxco

A non-representational mosaic by Carlos Merida designed in 1953 is also shown. Assembled in Venetian smalti it represents a departure from social-realism towards complete abstractism in a pattern of intersecting planes (162).

162 *Mural by Carlos Merida in Venetian Mosaic in the Entrance Hall of the Reaseguros Alianza building, Mexico DF (1953) (Courtesy of Carlos Merida)*

José Chauvez Morado, a most talented artist and designer in the medium of mosaic, finds expression for some significant allegorical comments in his work on the façades of civic buildings. On the theme of 'Medicine and Magic', he has designed a mural for the medical laboratories of Ciba in Mexico D. F.; macabre and dramatic in subject matter, Deaths seek to dominate the scene. The medium is glazed Mexican tesserae. Another work of Morada illustrated here is a section from the mural in the building of the Secretarial of Communications and Public Works on the theme of communication systems in pre-Spanish Mexico. It depicts warriors and gods with their torches, arrows, thunderbolts and drums, and is carried out in Mexican mosaics of stone, ceramic, and coloured glass.

His third work shown here is a detail from the mural in the Faculty of Science, City University, Mexico, executed in Venetian smalti. The subject is 'The Return of Quetzacoat', God of the Morning Star. The section illustrated shows clearly that the laying in of the tesserae is in some areas completely random while in others they follow directional lines to express strong form and movement (163, 164 and 165).

The lesson to be learned from the long history of mosaic would appear to be that it is an art form in its own right and although subject to changing techniques and ideologies, it only reaches its high noon when the imitation of other arts is avoided and the essential nature of the medium is respected.

163 Façade in 'Mexican' mosaics by José Chauvez Morado on the theme of 'Medicine and Magic in the Prehistoric Culture', at the medical laboratories of 'Ciba', Mexico DF in 1954 (Courtesy of José Morado)

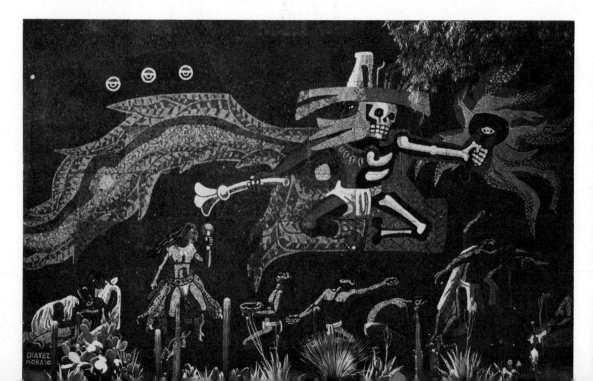

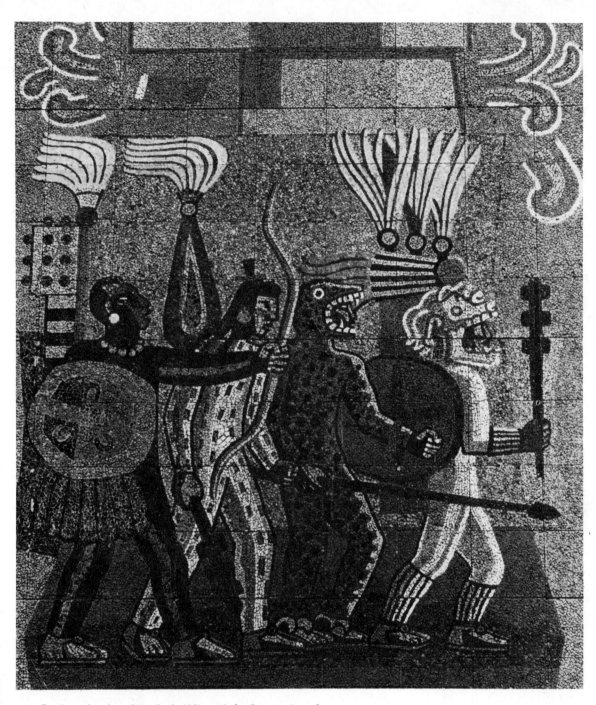

164 Section of a mural in the building of the Secretariat of Communications and Public Works, carried out in 'mexicano' mosaics of stone, ceramic and coloured glass on the theme 'Communications in Pre-Spanish Mexico', by José Chauvez Morado in 1953–4 (Courtesy of José Morado)

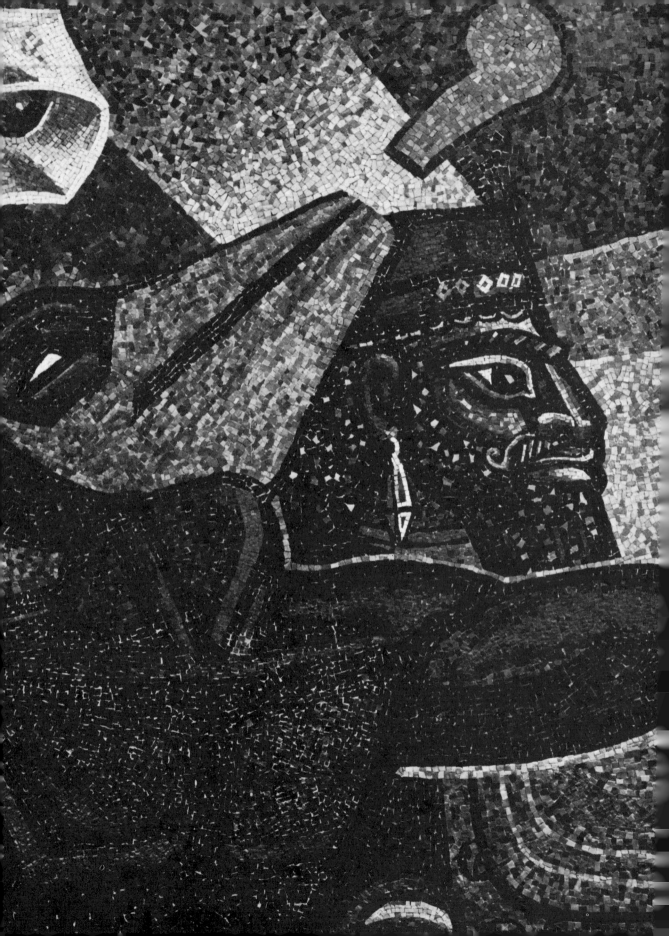

Glossary

Aggregate – An additive to concrete, generally in the form of gravel or granite

Biscuit firing – Preliminary low-temperature firing of the clay

Cartoon – The full-scale drawing, from which the final work is done

Ceramic – Clay which has been glazed and fired, generally having a coloured face

Chinagraph pencil – A wax pencil used for drawing on glass or glazed surfaces

Chipboard – A cheaper and heavier form of plywood with a centre filling of wood particles bound together with glue

Contour line – Line of direction taken by tesserae to describe form

Corbelling – Building out of brickwork to form a ledge of support

Encaustic tiles – Tiles in which the pigment is incorporated in the clay and not merely painted on the surface before firing

Expanded metal – A form of metal mesh for reinforcing concrete

Figurative and non-figurative – Figurative art seeks to depict the thing seen. Non-figurative art deals with abstractions

Filato – Minute glass rods cut in sections and used in small-scale mosaic jewellery

Fissile – A fissile mineral is one which splits fairly easily

Flashed glass – Glass in which colour is fused on to one surface only

Flint – An additive to the clay body

Flint knapping – The traditional craft of splitting and cutting flints

Glaze – A glass-like layer covering the surface of ceramic

Grout – A thin mortar used to fill the cracks between tesserae

Half drop – A staggered repeat of pattern (see fig. 2)

165 Section of mural in the Faculty of Science, University of Mexico DF by José Chauvez Morado in 1953–4, carried out in Venetian mosaic on the theme 'The Return of Quetzalcoatl' (Courtesy of José Morado)

131

Kiln wash – A substance to protect the kiln shelves against running glazes

Knocking up – The kneading of clay to prepare it for firing

Lead bisicilicate – A form of lead which has been rendered non-poisonous by firing

Leather dry – Partially dry clay which can still take an impression

Light-box – A wooden framework over which a sheet of frosted glass is laid to cover a strip light. For viewing the colours of stained glass

Linear design – Design of which the main part is line, or edge

Maquette – Small-scale model of the project

Monochromatic – Being of shades of one colour

Negative pattern – The shapes left between motifs

Reducing glass – A concave glass which acts in the opposite manner from a magnifying glass

Seger cone – Ceramic cones, numbered and marked at exact temperatures at which the tops bend in a kiln

Sgraffito – The scratching of a design either lightly or deeply on to the surface of the clay

Slip – Basically a liquid solution of the clay used in the body of the work which can have additions or colour added. It is painted or poured on to the surface before firing

Smalti – The name given to the tesserae which were used for traditional mosaics, manufactured in Italy

Tungsten lighting – Normal domestic light bulbs

Bibliography

Arvois, Edmond, *Making Mosaics*, Sterling Publishing Co Inc, New York; Oak Trees Press, London and Sydney

Billington, Dora and Colbeck, John, *The Technique of Pottery*, Batsford, London

Damaz, Paul, *Art in European Architecture*, Van Nostrand Reinhold, New York

Ellis, Clarence, *The Pebbles on the Beach*, Faber, London

Evans, I O, *Observer's Book on British Geology*, London

Fischer, Peter, *Mosaic, History and Technique*, Thames and Hudson, London

Haswell, J Mellintin, *Mosaic*, Thames & Hudson, London

Hendrickson, Edwin, *Mosaics, Hobby and Art*, Cornerstone Library, New York

Hetherington, P B, *Mosaics*, Hamlyn, London, New York, Toronto

Hutton, Helen, *Practical Gemstone Craft*, Studio Vista, London

Jenkins and Mills, *The Art of Making Mosaics*, Van Nostrand, Princeton, New Jersey

Lauppi, Walter, *Stein an Stein*, Verlag Paul Haupt, Bern, Switzerland

Lee Aller, Doris and Diane, *Mosaics*, Lane Book Co, California

Petas, Frantisek, *Medieval Mosaic*, Spring Books, London

Pugh, Frederick H, *A Field Guide to Rocks and Minerals*, Editorial by R T Peterson, Lapidary Journal Book Dept, USA

Rada, P, *Book of Ceramics*, Spring Books, London

Rogers, Cedric, *Minerals, Rocks and Gemstones in Cornwall and Devon*, D Bradford Barton, Devon

Röttger, Ernst, *Creative Clay Craft*, Batsford, London

Rule, Margaret, *Floor Mosaics in Roman Britain*, Macmillan, London

Saunders, Herbert H, *Practical Pottery Book*, Blandford Press, London

Scarfe, Herbert, *Collecting and Polishing Stones*, Batsford, London

Steers, J A, *The Coastline of England and Wales*, Cambridge University Press

Strache, Wolf, *Forms and Patterns in Nature*, Pantheon Books, New York

Unger, Hans, *Practical Mosaics*, Studio Vista, London

Whitmore, Thomas, *The Mosaics of Hagia Sophia at Istanbul*, Byzantine Institute, Oxford University Press, London

Williamson, Robert, *Mosaics*, Crosby Lockwood, London

Suppliers in Great Britain

CERAMICS

Kilns, kiln furniture, clay, glazes, slips, etc.
British Ceramic Service Co. Ltd, 1 Park Avenue, Wolstanton, Newcastle, Staffs
Fulham Pottery Ltd, 210 New Kings Road, London SW6
Podmore and Co. Ltd, Caledonian Mill, Shelton, Stoke-on-Trent, Staffs
Webcot Ltd, Alfred Street, Fenton, Stoke-on-Trent, Staffs

MORTARS AND ADHESIVES

All builders' merchants supply concrete, ciment fondu, *Sirapite*, lime and sand
Ciba Ltd, Duxford, Cambridge
Araldite adhesives and epoxy resins
Joseph Freeman and Sons Ltd, 96 Garratt Lane, London SW18
Cementone products
Nicholls and Clarke Ltd, Shoreditch High Street, London E1
Nic-o-Bond Thikbed and tile cement
Richard Tiles Ltd, Tunstall, Stoke-on-Trent, Staffs
Richafix adhesive, tiles and mosaics
Unibond adhesive
Bondcrete adhesive Most builders' merchants
Evostik adhesive

STAINED GLASS

Stained glass of all types, slab glass
James Hetley and Co. Ltd, Beresford Avenue, Wembley, Middlesex

TESSERAE

(Most mosaic materials). Vitreous, glazed and unglazed ceramics, smalti, marble pieces, cubes, mosaic paper, gum, setting trays, hammers, cutters, *Mosicfix* adhesive, *Fixtite*
Bush Crafts Ltd, 25–27 Bramley Road, London W8
(Most mosaic materials). Wood panels, table legs, squared paper, gummed mosaic paper, Byzantine smalti mosaic for murals, smalti mosaic—thin strips, *Saivo* Italian glass mosaic, *Mosacol* cement, cutters
Proctor and Lavender Mosaics, Solihull, Warwickshire
Kosta glass mosaic (Swedish), squares and oblongs
Edgar Udney and Co. Ltd.

Most of these firms will send mail orders to any part of the USA.

Mosaic Crafts Inc., 80 West 3rd Street, (nr 6th Avenue), New York City

Vedovato Brothers Inc., 246 East 116 Street, New York City

Dillon Tile Co., 252 12th Street, San Francisco, California

American Mosaic Co., 912 First Street NW, Washington DC

Gager's Handicraft, 1024 Nicollet Avenue, Minneapolis, Minnesota

Ravenna Mosaic Co., 3126 Nebraska, St Louis, Missouri

Suppliers of Magnesite (mortar)

Berkshire Chemicals Inc., 155 East 44th Street, New York City

Kaiser Aluminium Chemical Sales Inc., 300 Lakeside Drive, Oakland, California

Glazes and kilns

H. B. Selby and Co. Pty Ltd, 393 Swanston Street, Melbourne, Victoria, (also addresses in Sydney, Adelaide, Brisbane, Hobart, Perth. See local directories)

Ceramic and glass mosaic, smalti, ceramic tiles

W. M. Crosby (Merchandise) Pty Ltd, 266–274 King Street, Melbourne (also at Hobart, Launceston, Perth, Sydney, Brisbane, Adelaide. See local directories)

Ceramic raw materials, potting clays

Rodda Pty Ltd, 62 Beach Street, Port Melbourne, Victoria. Agents in all states and in New Zealand. Sole Australian Agents for Pike Brothers: Fayle and Co. Ltd, producers of Dorset ball clay

Pottery clays, ceramic glazes and American 'Tru-Fyre' ceramic glazes

Camden Art Centre Pty Ltd, 188–200 Gertrude Street, Fitzroy, N.6. Victoria

Index

Abd-el-Malik, Caliph, builder of
Dome of the Rock, Jerusalem
120

Abstract nature designing 10–11

Al-Walid, Caliph 120;
commissions artists to carry
out pictorial mosaics in Great
Mosque, Damascus 120

Albert Memorial, London 122;
example of indirect or reverse
method of laying tesserae 122

Alexandria, as important cultural
centre 113

Alhambra tiles 14

Ammonite fossils 93

Anrep, Boris 122; designer of
floor murals 122

Art Nouveau movement 123

Artificial light, use of 20

Badger brush and ink, use of 19

Bark, tree 7: best use of on large-
scale projects 16; use of 6, 10,
12, 31–2, 99–100

Bark and oyster shell, figure of
cock made in 103

Bark and seed mosaic 101:
materials 101–2; method of
working 102

Bark mosaics 99–103; designing
mosaic with 100; equipment
needed 100

Barytes 28

Bazaine 123; work on Sacred
Heart Church, Audincourt,
France 123

Beans: small, ideal for small scale
decorative panels 16; use of 6,
10, 31–2

Belloni, Francesco 122; work
done in Melpomene Room in
Louvre, Paris 122

Bench, use of in workroom 22

Berlin, Wagner workshops in
122

Bookshelf, in workroom,
provision for 22

Bottle glass 27, 73

Braccia 93

Braque, Georges 123

British Museum, London 115;
examples of black and white
abstract patterns in 115

Byzantine civilization as
contributor to rhythm-colour

pattern form 8

Byzantine period, famous for
repetitive pattern and motif 14

Capitoline Museum, Rome 123;
copies of works to be seen in
122–3

Carbons, use of 19

Ceramic tesserae 11, 60–71:
commercial, smoothness and
shininess of 10; equipment 60;
materials 60–1

Ceramic tiles: mural 42–6;
materials 43; method of
working 43; (set with direct
adhesive) 70–1; materials 70;
tools 71; method of working
71

Ceramics: encaustic 26; glazed 26

Chedworth, Roman villa at 117

China, broken, as ceramic
material 26

Christianity as golden age for
mosaics 116

Cimabue, Giovanni 121;
commissioned to undertake
mosaics in Pisa cathedral 121

Clay, modelling 61: sources of
supply 61; preparing newly
dug 61, 109; preparation of
62–3
 surface treatments applied
 before glazing 63–4;
 impressing 63–4, 65;
 sgraffito 64; wax resist 64;
 flashing 64; pattern painting
 64; sanded texture (raised)
 64;
other textures 65; slips 65;
glazing 65–6; applying slips
and glazes 66–7; firing 67–8

Coffee table, application of
mosaics on 50–3: materials 50;
tools 50; method of designing
50–1; method of working 51–3

Colour: can be naturalistic or
formalized 13; variation in
quality of in differing types of
tesserae 13

Commercial vitreous or seeds 11

Constantinople 121; surviving
mosaics in 121

Contrast 15: plainest example of
15; practical ways of bringing
about c in mosaics 15

Corinium Museum, Cirencester
117; pavemental mosaics in
117

Cottenham Village College 99:
seed mosaic made by children

of 100; materials 100; method
of working 100

Cotton or wool material, to make
glued patchwork mosaic 32

Crockery, broken, to make
mosaics 7

Cupboard 20; storage 22

Damascus, Great Mosque,
pictorial mosaics in 120

Delos, magnificent mosaics on
112

Design(ing): non-figurative,
ideas and inspiration for 8–11;
abstract 10–11; figurative 11;
importance of colour and tone
in mosaic 12–13; random 16,
19, 70

Dimension 15–16

El-Ubaid, Iraq, Sumerian
column at 111

Emblema(ta) 113–15; portability
of 115

Emery paper, 'wet-dry' 87

Enlargement, small sketch to
working size cartoon, method
of 18–19

Equipment, carpentry 221 for
clay work and glazing 23

Fairs, Tom 82–3; glass filament
mosaic by 82–3

Fishbourne Roman Palace,
Chichester, floor mosaics at
113, 116–17

Flint 84

Flint-knapping 84, 87

Flour and water paste 109

Flowerpots, broken, as ceramic
material 26

Fluorspar 28

Form: organization of into
repetitive pattern 14; to be
observed from distance 14–15

Forseth, Einer 122; designer of
mural for Golden Room in
Stockholm City Hall 122

Function 15–16

Futurism movement 123

Gaudi, Antonio 123, 125;
outstanding contribution by to
twentieth-century mosaic 123;
outstanding works in
Barcelona 123

Geological Museum, London 28,
91

Ghirlandaio, Domenico 121;
designs in Florence cathedral